Architectural Rendering with 3ds Max and V-Ray

Photorealistic Visualization

Markus Kuhlo
Enrico Eggert

ELSEVIER

AMSTERDAM • BOSTON • HEIDELBERG • LONDON • NEW YORK • OXFORD
PARIS • SAN DIEGO • SAN FRANCISCO • SINGAPORE • SYDNEY • TOKYO
Focal Press is an imprint of Elsevier

Focal Press

Focal Press is an imprint of Elsevier
30 Corporate Drive, Suite 400, Burlington, MA 01803, USA
The Boulevard, Langford Lane, Kidlington, Oxford, OX5 1GB, UK

Notices
Knowledge and best practice in this field are constantly changing. As new research and
experience broaden our understanding, changes in research methods, professional practices,
or medical treatment may become necessary.

Practitioners and researchers must always rely on their own experience and knowledge in
evaluating and using any information, methods, compounds, or experiments described
herein. In using such information or methods they should be mindful of their own safety
and the safety of others, including parties for whom they have a professional responsibility.

To the fullest extent of the law, neither the Publisher nor the authors, contributors, or
editors, assume any liability for any injury and/or damage to persons or property as a matter
of products liability, negligence or otherwise, or from any use or operation of any methods,
products, instructions, or ideas contained in the material herein.

Library of Congress Cataloging-in-Publication Data
Application submitted

British Library Cataloguing-in-Publication Data
A catalogue record for this book is available from the British Library.

ISBN: 978-0-240-81477-3

For information on all Focal Press publications
visit our website at www.elsevierdirect.com

Typeset by: diacriTech, Chennai, India

Printed in the United States of America
10 11 12 13 14 5 4 3 2 1

Architectural Rendering with 3ds Max and V-Ray

Contents

Introduction and Theory

Preface

We are glad that you have decided to purchase this book on architectural renderings with 3ds Max and V-Ray. We hope that you will enjoy reading the book and the opportunity to learn new things while working through the lessons. We trust that you will be able to apply this information in your future projects. The book is divided into six chapters. The first chapter focuses on theoretical knowledge. The information provided in this section spans a range, from light in real life via computer graphics to its significance in architecture. We will discuss sources of light specific to V-Ray, as well as materials and cameras. Different render algorithms and their advantages and disadvantages will be introduced. The other five chapters show you how to proceed with 3D Studio Max and V-Ray, workshop-style. Architectural scenes and lighting scenarios are described, from opening the file to the final rendering settings. We decided to use V-Ray as the rendering plug-in, because it is a very fast, high-quality renderer and is available for all commonly used 3D software solutions.

Architectural Rendering with 3ds Max and V-Ray. DOI: 10.1016/B978-0-240-81477-3.00005-3

V-Ray is now available for Cinema 4D, SketchUp, Rhinoceros, and 3ds Max, to name a few. There is also a current beta version of V-Ray for Maya. The parameters and theories that the settings are based on are the same in all applications, which makes this book interesting for many users, not just users of 3ds Max.

Have fun and enjoy working with V-Ray!

Acknowledgments

From Markus
I want to thank my family and my wonderful fiancé Rili, who always supported me. I also want to thank the team at ScanlineVFX for allowing me to learn so much and being able to see new tricks there.

From Enrico
I am grateful to my family for their moral support. To them and to my closest friends, I owe thanks for being so understanding about how I was able to spend so little time with them. My good friend Anja deserves special mention for her great support in every respect during the last few weeks before completion.

I owe special thanks to Dr. Marcus Kalusche of archlab.de, who always supported me and provided valuable advice. Many thanks also to our technical editor Florian Trüstedt. He readily supported us with his technical expertise. We also wish to thank our publishing editor at Pearson, Brigitte Bauer-Schiewek, for assisting us throughout the creation of this book.

Who Is This Book Intended For?

The book is mainly intended for computer graphics artists, enthusiastic users, and students of all disciplines who want to present their drafts, products, and ideas in three dimensions. Primarily, it obviously addresses students of architecture and interior design, where ideas are often conveyed through the medium of renderings. Furthermore, this book is meant to offer experienced architects and creative people access to the world of three-dimensional computer graphics. We hope to accomplish this through clear and straightforward presentation of the basics and by offering various problem-solving strategies as well as helpful tips for daily production tasks. You should already have a basic understanding of the user interface and operation of 3ds Max. As we focus primarily on light, materials, and settings for V-Ray rendering, it would be beyond the scope of this book to explain the basic elements of 3ds Max. It would also be helpful if you have previous experience with AutoCAD. Some of the models on which the scenes are based have been constructed in AutoCAD and are linked with 3ds Max. Here, emphasis is placed on using AutoCAD layers.

Basics of Architectural Visualization

The primary purpose of every picture is to impart an idea, concept, or draft. Sketches and templates for image formation are not necessarily required but can be very helpful. In architectural visualizations, photorealistic pictures are not in great demand. Instead, abstracted renderings are sought after in order to elaborate the idea and eliminate unimportant elements. Good communication with your client is therefore very important: you have to be speaking the same language, so to speak. It is also helpful to have a certain amount of background knowledge about your client's trade.

More concrete basics are a three-dimensional, digital model, reference photos of the surroundings, and materials or even mood pictures. You should build a well-structured database of fixtures and fittings, textures, background images, and other accessories. This database will grow rather large over time, so it needs to be properly arranged.

We do not want to comment in great detail on technical equipment, as it constantly needs to be updated. We recommend that you have at least two computers. One should be a workstation with an up-to-date, powerful processor; a lot of RAM; a good graphics card; and two monitors. Ideally, one monitor should be at least 24 inches (diagonally) to allow comfortable working. You are going to be working on this computer, while the other one calculates your pictures. The second computer does not require a powerful graphics card or monitors. If possible, you should use processors of the same type.

In addition to your knowledge and your equipment, you will need a lot of patience and of course a great deal of inspiration for creative computer work.

Considerations Regarding Light

In this section, we are going to approach the topic of light from three angles: its observation in real life, its translation within computer graphics, and its significance in architecture.

Light in the Real World

Perception and Mood

First, it must be said that the topic of "light" is far too complex for us to sufficiently explore here. We are going to comment on only a few aspects regarding atmosphere and phenomenology.

In everyday life, we rarely think about light in the real world, although it is present everywhere. But we are so used to the conditions of reality that we notice immediately if something is not real. Consequently, we would

almost always notice a difference between a computer-generated picture and a photograph. This is mainly due to differences or errors in computer-generated presentations of light. Almost anyone can notice that these diverge from reality, but only a trained eye can actually specify the differences.

Light has a subconscious influence on our feelings; it can stimulate emotions and create atmosphere. For example, when we are watching a sunset, we might feel romantic. Depending on its color, light can have a calming effect or make us feel uncomfortable. Think of the difference between warm candlelight and a corridor with the cold light from fluorescent tubes. Creating moods therefore requires conscious and deliberate observation of our surroundings.

In the real world, there are three lighting scenarios. The first one is natural light, which means sunlight shining directly or indirectly onto Earth, such as moonlight or through a layer of clouds. Natural and weather phenomena provide an exception—for example, lightning and fire. The second scenario is artificial light: any light that is not of natural origin, but manmade. This includes electric light, but also candlelight. The third and most common scenario is a simultaneous occurrence of both natural and artificial light.

One of the first discussions you should therefore have with your client is determining which of these scenarios is present in the picture you are going to create.

Some units of measurement in dealing with light:

- *Luminous flux (lumen):* Describes the radiated output of a light source per second
- *Luminous intensity (candela):* Describes the luminous flux which is emitted in a certain direction
- *Illuminance (lux):* Describes the luminous flux which arrives at a certain surface
- *Luminance (candelas per square meter):* Describes the luminous flux which is emitted from a certain surface

Illuminance

Light is subject to a series of rules. Three of these are of great importance in computer graphics. The first rule is that the illuminance decreases with the square of the distance from the light source. This means that a surface of one meter square that is one meter away from the light source is illuminated with the full assumed luminous intensity of the light source. If you increase the distance by another meter so that it is now two meters, the illuminance is only a quarter of the luminous intensity. At a distance of three meters, the illuminance is only a ninth of the luminous intensity. The luminous intensity always remains constant.

The two other important qualities are the reflection and refraction of light. If light hits a surface, a certain amount of it is absorbed and the

FIG 1.1 Light Source without Decrease in Illuminance.

FIG 1.2 Light Source with Natural Decrease in Illuminance.

FIG 1.3 The Blue Floor Makes the Entire Scene Look Blue.

FIG 1.4 The Multicolored Floor Affects the Coloration of the Surrounding Objects, Depending on its Surface Color.

rest reflected. The reflected part is the determining factor that enables us to perceive objects. An object that absorbs 100 percent of light appears completely black to us. White surfaces reflect most of the light. The darker and rougher the surface, the less light it will reflect and the more it will absorb. An object always reflects light in its object color, which can lead to what is called *color bleeding*, or the bleeding or overlapping of colors onto other objects.

The refraction of light occurs if light travels through a translucent medium with a different density than that of the medium in which the light was before. Again, the light will take on the color of the material.

Light travels at the speed of light, which is measured inside a vacuum. If the light's speed is decelerated by a change in density, there will be refraction. The refractive index or *index of refraction* (*IOR*) can be determined for each material. It measures how much the speed of light is reduced when passing from air into the medium.

FIG 1.5 Refraction; Glass Cuboids with Varying IOR.

The following table contains some examples.

TABLE 1.1 Overview of Refractive Indices

Medium	IOR	Medium	IOR	Medium	IOR
vacuum	1	quartz	1.46	flint glass	1.56–1.93
air (near the ground)	1	Plexiglas®	1.49	glass	1.45–2.14
plasma	0–1	crown glass	1.46–1.65	lead crystal	Up to 1.93
ice	1.31	polycarbonate	1.59	zircon	1.92
water	1.33	epoxy	1.55–1.63	diamond	2.42

The Color Temperature of Light

The color temperature of light has been measured in Kelvins since William Thompson Kelvin realized that carbon emits different colors depending on its temperature. In blue light, the red and green components of the light source are lower or nonexistent. Under these circumstances, all red and green objects would appear black. When using colored light sources, you therefore need to make sure to always mix a certain proportion of all colors to avoid black objects.

FIG 1.6 Cuboids with the Three Primary Colors and their Combinations, White Light.

FIG 1.7 The Same Cuboids, Red Light (R:255; G:0; B:0).

FIG 1.8 Cuboids, Green Light (R:0; G:255; B:0); Here You Can See Clearly that the Green Portion is the Largest in Our Color Spectrum.

FIG 1.9 The Same Scene, Blue Light (R:0; G:0; G:255).

The following table contains an overview of several color temperatures.

TABLE 1.2 Overview of Color Temperatures

Type of light	Kelvin	Type of light	Kelvin	Type of light	Kelvin
Candle light	up to 1900	Neutral white	5000	Cloudy north sky	6500
Warm white	Up to 3300	Sun at noon (summer)	5100–5400	Daylight white	5000–6800
Light bulbs	2200–3400	Cloudy sky (January)	5900–6400	Blue sky at noon (December)	9900–11500
Fluorescent tubes	Over 3900	Xenon lamp	6500		

Color Temperature and Its Effect

Colored light is very important, for example, to express the time of day. The color of the light in the morning has a different proportion of red than the light of the setting sun. The color of daylight also depends on the place, the time of year, and the weather conditions while you observe it.

Shadow

The shadow being cast is not really a property of the light, but rather a property of illuminated objects. A shadow in itself is the absence of direct light and mostly refers to a diffusely illuminated area. Shadows always appear behind objects that are positioned in front of a light source. The shadow area does not necessarily have to be darker than the directly illuminated area. Transparent objects, for example, also cast a shadow and can even produce lighter shadows, due to a concentration of rays of light or caustics.

Shadows play a very important role: they indicate the position and type of the light source. Without shadow, a picture cannot have any spatial depth.

An object that does not cast a shadow appears unrealistic, as if it were always floating. Parallel shadows do not occur in nature; they can be created only by artificial light.

Light in Computer Graphics

Unlike in the real world, the light in computer graphics is not subject to any restrictions. You therefore have many options and great freedom, but it becomes more difficult to produce realistic illuminated scenes. A watchful eye is required to achieve a rendering that appears realistic. Sometimes one light source is not enough and you have to resort to tricks in order to achieve a result that appears realistic or expresses the desired idea.

Consider possible scenarios of illumination:

- Location of scene, time of year, and time of day
- Indoors, artificial light, sunshine with clear sky
- Indoors, artificial light, cloudy sky
- Indoors, only artificial light
- Exterior view of a building, sunset, artificial light inside

Ask yourself which atmosphere you want to convey:

- Do I want to create a calm atmosphere or a romantic one?
- Do I want to draw to attention to something in particular?
- Is there a reference that I need to integrate my rendering into?

Get an overview of the light sources and their qualities:

- Standard light sources
- Point light, spot light, parallel light
- Create even illumination
- Are not subject to physical laws
- Photometrical light sources
- Point light, plane light
- Are essential for physically correct illumination
- Can be expanded with IES profiles
- Are based on physical units
- Daylight systems
- Even, diffuse lighting (sky) and direct illumination (sun)
- Light-emitting materials
- For representing luminescent, such as neon tubes or monitors
- Render-engine-specific light sources
- Dependent on the render engine used (V-Ray, Mental Ray, Maxwell, Brazil)

These are some tips when working with light:

- Try to work with surrounding light that corresponds to natural light from the sky to light the scene diffusely.
- The main light should always be clearly noticeable.

- Pay more attention to convincing light setup than physical correctness.
- The shadows are as important as the light.
- Become familiar with materials in reality and their physical properties.
- Hardly any material has a completely smooth surface; the irregularities affect the light distribution on the surface.
- Highlights help the viewer to determine the quality and nature of a material, but not all materials have hard highlights.
- No two materials are the same; the differences in surface appearance create a more realistic effect.

Light in Architecture

Light has always played a decisive role in architecture. Light creates atmosphere, can make rooms appear bigger or smaller, and can emphasize details or hide them. The first great buildings that specifically employed light were religious buildings. Initially, they did not let much natural light in, in order to emphasize the few existing windows. The windows seemed to shine, creating a mystical effect.

Light and architecture are closely linked; light presents good architecture favorably, but can also show mistakes. During the day, the light wanders across the façade, constantly giving it a different appearance. Architects have always used this medium, from the old master builders of temples and churches to famous architects of today, such as Tadao Ando, Jean Nouvell, or Louis I. Kahn. Light can also be used as an effect in architecture, such as the Empire State Building, with its varying illumination for different occasions. The use of artificial light is of particular importance in exhibition architecture, whereas daylight plays an important role when constructing domestic buildings.

V-Ray

Let's now turn our attention to the render engine V-Ray. We will begin with some product specifications that convinced us to work with this product; then we will comment on the methods for light calculation and introduce some features specific to V-Ray. Last, we will discuss linear workflow.

Why V-Ray?

Here is a list of the product features that we particularly appreciate during our daily production tasks:

- V-Ray is platform-independent and available for many 3D programs.
- The parameters are the same for the different applications.
- The product is relatively cheap.

- The quality of the pictures is in good proportion to the render time.
- V-Ray is constantly being updated.
- There is a large worldwide community.
- V-Ray is used widely, also in the film and advertising industry.
- It has excellent displacement.
- It supports IES data, an important factor for architectural visualizations.
- Version 3 and later also support Mental Ray materials.
- V-Ray is very well integrated into the 3D programs.

Indirect Illumination

The calculation of indirect illumination in V-Ray is divided into two processes, which can be combined in different ways:

- Primary bounces—The light is emitted from the light source onto the scene until it hits an object. The first complex calculation takes place here, and the light is scattered, absorbed, refracted and reflected.

FIG 1.10 Rendering without Global Illumination.

FIG 1.11 Rendering with Global Illumination.

- Secondary bounces—Starting from the point where the primary bounce hits the geometry, the light is spread around the scene once more in this calculation process, achieving diffuse illumination of the scene.

If you did not activate the calculation of global illumination, only the process of primary bounces is applied automatically.

In the following section, we will introduce the various render algorithms with their advantages and disadvantages.

Brute Force

The BRUTE FORCE algorithm calculates the GI (global illumination) for each pixel in the picture.

Advantages:

- Few setting options
- Very consistent results
- Reveals even small details
- Only little flickering in animations

Disadvantages:

- Very high render times, especially in complex scenes

Renderings are partly affected by severe noise, especially in darker image areas, which can be remedied only by higher render settings and therefore very long render times.

Irradiance Map

The IRRADIANCE MAP algorithm calculates the GI depending on the complexity of the scene with different accuracy. Interpolation takes place between the calculated areas. A multitude of setting options is available and can be managed well with a selection of presets.

Advantages:

- In comparison with the brute force algorithm, this produces shorter rendering times for the same complexity of scene.
- No noise in darker image areas.
- The irradiance map—the result of the calculation—can be saved and reused, which can drastically reduce the render time for animations.

Disadvantages:

- Due to interpolation, fine shadows can be lost in detailed areas.
- Animations can be affected by flickering, which can be remedied by saving the irradiance map as a multiframe incremental map (i.e., provided that the output frame sizes are equal).
- Requires a lot of RAM.

- Very complex setting options.
- The light solution is dependent on the location—only the visible portion of the scene is calculated.

Photon Map

For the PHOTON MAP algorithm, photons are emitted from all light sources in the scene and then bounced around between objects until their energy is used up. Only true light sources are taken into consideration, not surrounding illumination or luminous materials. The algorithm is useful for interior scenes with many light sources and achieves good results with short rendering times when used in combination with irradiance map.

Advantages:

- Very fast algorithm.
- Location-independent.
- The photon map can be saved, but changes in material, light, and position of objects are not possible.

Disadvantages:

- Very imprecise calculation; usage under primary bounces is not recommended.
- High memory requirements.
- Restrictions in selecting light sources.

Light Cache

This algorithm functions in a similar way to the photon map, but the photons are emitted into the scene from the camera and the algorithm can be used for any kind of scene.

Advantages:

- Simple setup.
- Very quick calculation.
- Very fast, good results in combination with the irradiance map.
- Very precise calculation of contact shadow and shadows in corners.
- Preview during calculation process; therefore, serious mistakes can be spotted quickly.

Disadvantages:

- Location-dependent; has to be recalculated every time.
- Problems in calculating *bump maps*, but this has no effects when used for secondary bounces.

Finally, we would like to offer you some guidance by comparing the most sensible combinations for an interior scene and an outdoor scene. For the first comparison, we refer only to the quality of the result; for the second

comparison, we relate the quality to the rendering time. We are analyzing only stationary images—these comparisons are not necessarily applicable to animations.

Interior Scene

Criteria: Quality

The best quality is produced by a combination of the algorithms BRUTE FORCE (primary bounces) and LIGHT CACHE (secondary bounces). Hardly any artifacts occur, and even in detailed image areas, the accuracy remains high. A clear disadvantage, however, is the long rendering time.

Criteria: Time invested in relation to quality

In this case, we recommend a combination of IRRADIANCE MAP (PRIMARY BOUNCES) and LIGHT CACHE (SECONDARY BOUNCES). The calculation is very quick and exact, even in detailed image areas. Possible errors can usually be fixed by selecting a better preset. This combination is the better choice for everyday work.

Exterior Scene

For the exterior scene, the same applies as for the interior scene. The calculation can potentially take even longer in this case, as the scene has a higher number of polygons due to trees, bushes, and lawn, and therefore more detailed areas.

We can therefore conclude that the combination of IRRADIANCE MAP and LIGHT CACHE is the most appropriate. As there is an exception to every rule and sometimes the rendering time is irrelevant, you should not completely disregard the other algorithms.

Ambient Occlusion

In areas where two or more objects are touching, there is insufficient light, and these areas appear darker in comparison to the surroundings. These darker areas are called *contact shadows* (*ambient occlusion* or *AO*). Ambient occlusion is always calculated without direct light, and with only a diffuse surrounding light. In V-Ray, there are several options for calculating the ambient occlusion. For example, you can output it as a separate rendering channel, resulting in a grayscale image. In an image editing program, you can multiply this image with the actual rendering. Only certain image areas are darkened, as the image consists of color values between one and zero. In this book, we use a VRayDirt material for objects that are to have a contact shadow. In this case, the ambient occlusion is already saved in the output image. As you can adapt the parameters for each material, you have good control over the contact shadow.

FIG 1.12 Ambient Occlusion Channel.

FIG 1.13 Diffuse Channel, Rendered without a Light Source.

FIG 1.14 Result of Overlaying Both Channels.

VRayLight

Using V-Ray light sources (VRAYLIGHTS) is the best choice when working with V-Ray. These light sources behave with physical correctness. Unlike standard light sources, the light is emitted by a three-dimensional source, not by one point. VRayLights require shorter rendering times, have integrated falloff as the standard, and always produce a realistic-looking area shadow. There is a choice of four light sources:

1. Plane
- The light is emitted by an area (i.e., from the light flux direction of the plane object only).
- The bigger the light source, the more light is emitted and the softer the shadows it produces.

FIG 1.15 VRayLight, Type Plane.

2. Sphere
- The light is emitted by a three-dimensional sphere.
- The bigger the light source, the more light is emitted and the softer the shadows it produces.

FIG 1.16 VRayLight, Type Sphere.

3. Mesh
 - The light source can be linked to a three-dimensional object and emits light from its geometry.
 - The bigger the light source (the object), the more light is emitted and the softer the shadows it produces.

FIG 1.17 VRayLight, Type Mesh.

4. Dome
 - The light is emitted evenly into the scene in order to achieve diffuse illumination without applying GI, especially for exterior visualizations.
 - The position and size of the light source have no effect; it should not be rotated in direction x or y.

FIG 1.18 VRayLight, Type Dome.

FIG 1.19 VRayLight, Dome with 90-Degree Rotation.

The V-Ray light sources have almost the same parameters as standard light sources. A big difference is the option to be able to work with different units of light intensity. Here is an overview of these units:

- Default (image)
 - No relation to physical values; this is based on the multiplication system internal to 3ds Max.
 - Light intensity and shadows depend on size of light source.
- Luminous power (lm)
 - Is measured in lumen (luminous flux).
 - Physically correct unit, size of light source has no impact.
- Luminance (lm/m^2)
 - Physically correct values for light intensity can be looked up in catalogs provided by lighting manufacturers.
 - The size of the light source has decisive impact.
- Radiant power (W)
 - Measured in watts, describes the total energy that is emitted from a light source.
 - During application, it is important to remember that a light-bulb, for example, transforms most of its energy into heat, which means the value of 100 watts for a lightbulb cannot be directly transferred.
 - The size of the light source has no impact.
- Radiance (W/sr/m^2)
 - Indicates the total energy of a light source per solid angle per square meter.
 - The size of the light source influences the total energy emitted by the light source.

VRayIES

Companies that produce luminaires and lamps can provide so-called IES files. These enable you to simulate real luminaires with physical correctness. Their behavior corresponds to a three-dimensional object that emits light,

just as in reality. The emission properties of the lamps and the effects of built-in reflectors are taken into account. The light distribution within the room and on the walls appears more realistic than using standard light sources. It is important to activate the option USE LIGHT SHAPE in order to calculate soft shadows as they appear when using a three-dimensional light source in reality. The rendering time is longer, but this is compensated for by increased realism.

FIG 1.20 VRayIES, IES File by Company Erco.

VRaySun

The VRAYSUN is a V-Ray-specific light source, and its way of functioning differs from that of other light sources. It simulates a daylight system, composed of sun (direct light) and sky (diffuse light). When creating a VRAYSUN, a VRAYSKY shader is automatically placed into the channel of the environment map. The VRAYSUN has the same intensity as the real sun. The color and the light intensity of the VRAYSUN are determined by its position, just as with the real sun.

FIG 1.21 VRaySun, Time 06:00.

FIG 1.22 VRaySun, Time 08:00.

FIG 1.23 VRaySun, Time 10:00.

FIG 1.24 VRaySun, Time 12:00.

FIG 1.25 VRaySun, Time 14:00.

FIG 1.26 VRaySun, Time 16:00.

FIG 1.27 VRaySun, Time 18:00.

FIG 1.28 VRaySun, Time 20:00.

For example, the lower the sun, the softer the shadows. In this respect, the value INTENSITY MULTIPLIER —which sets the intensity—cannot be compared to other light sources. There are two possibilities of working with the sun system. For one, you can set the intensity in the multiplier to *0.001* in order to be able to use it with other light sources without exposure compensation. This is not recommended, however, as the result is not physically correct. The better method is using the physical camera, VRAYPHYSICALCAM.

FIG 1.29 VRaySun, without VRayPhysicalCam.

Here is a brief introduction to the main parameters of VRAYSUN:

- Turbidity
 - Haziness, degree of air pollution
 - The higher the value, the lower the amount of sun that gets through, the softer the shadows become, and the redder the picture is tinged.

22

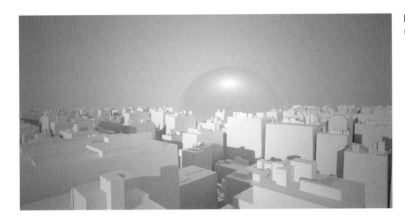

FIG 1.30 VRaySun, with VRayPhysicalCam.

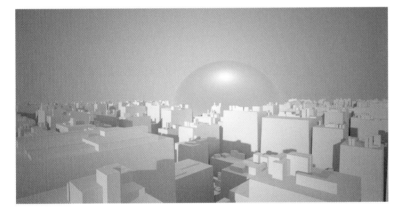

FIG 1.31 Turbidity 3.

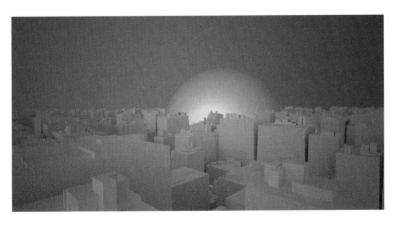

FIG 1.32 Turbidity 10.

- Ozone
 - Affects the color of the light, yellow for a value around *0*, blue for a value near *1*

FIG 1.33 Ozone 0.35.

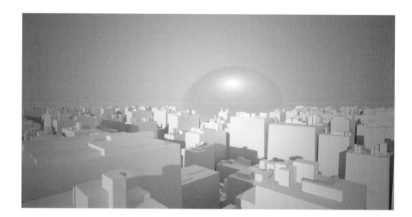

FIG 1.34 Ozone 1.

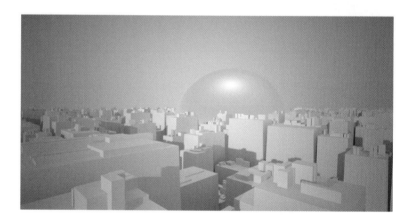

- Intensity multiplier
 - Light intensity of the sun, the value *1.0* is physically correct, but only to be used in combination with the VRayPhysicalCam.
- Size multiplier
 - Affects the size of the sun.
 - The larger the sun, the softer the resulting shadows.
 - We recommend values between *0.5* and *5*.
- Shadow subdivs
 - The higher the value, the better the resolution of the shadows and the quality, but the rendering time will also be longer.
 - We recommend values between *8* and *64*, depending on distance between observer and shadow.

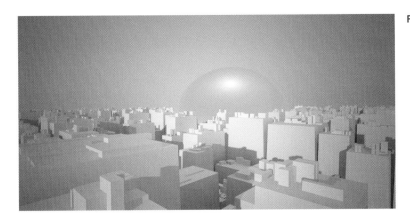

FIG 1.35 Size Multiplier 1.

FIG 1.36 Size Multiplier 10.

- Shadow bias
 - Moving an object's shadow away from the object.
 - Values below *0* move the shadow away from the object; values above *0* pull the shadow closer to the object.
 - Choose values slightly above *0* in order to obtain realistic results and avoid errors in calculation.
- Photon emit radius
 - Within this radius, photons are emitted that can be used for calculating caustics.

VRaySky

VRAYSKY offers the same setting options as the sun and is by default linked to the sun. It influences the diffuse light incidence within the scene. The shader with which the parameters can be set is located in the ENVIRONMENT MAP channel in the ENVIRONMENT AND EFFECTS dialog box. The sky can therefore be accessed independently from the sun's position, and each can be adjusted on its own by enabling the manual sun node function.

FIG 1.37 Rendering with Sky and Sun Linked.

FIG 1.38 Rendering with Separate Sky; the Shadows Remain the Same, but the Sky's Ambient Light Changes.

Here we offer a brief overview of the advantages and disadvantages of VRaySun and VRaySky (the daylight system).

Advantages:

- Easy to set up and modify.
- Good results with little effort.
- Physically correct.
- Well suited for daylight situations.

Disadvantages:

- Longer rendering times in comparison with standard light sources.
- Limited adjustment options.
- Additional light sources in the scene have to work with photometrical data.
- Working with VRayPhysicalCam requires knowledge of photography.

VRayPhysicalCam

The application of the VRᴀʏPʜʏꜱɪᴄᴀʟCᴀᴍ enables working in V-Ray with physically correct values. In combination with VRᴀʏSᴜɴ and VRᴀʏSᴋʏ, it can be used to perfection. Using physically correct light sources is a requirement. The advantages in comparison to the standard camera are physically correct calculation of depth of field blur, motion blur, and bokeh effect (explained later in this section). The parameters, such as the exposure time, are equivalent to those of a real camera. The disadvantage is a comparatively long rendering time.

Here once again an overview of the most important parameters.

Basic Parameters
- Type
 - Selection of different camera types, camera (Sᴛɪʟʟ Cᴀᴍ), film camera (Mᴏᴠɪᴇ Cᴀᴍ), digital video camera (Vɪᴅᴇᴏ Cᴀᴍ).
 - Affects aperture and therefore appearance of blur.
- Targeted
 - If activated, the camera has a target point.
 - Very helpful for working with depth of field blur.
- Filmgate (mm)
 - The camera's sensor size.
 - Important for matching the camera to the photograph (camera match).
- Focal length (mm)
 - The camera's focal length.
- Zoom factor
 - The camera's zoom factor.
- F-number
 - Relative aperture of the camera, analog to photography.
 - Affects brightness if the Exᴘᴏꜱᴜʀᴇ option is activated.
 - Affects depth of field blur.
- Guess vert./Guess horiz. shift
 - Camera correction, removes perspective distortion; at times you may have to tweak its parameters.
- Exposure
 - If activated, parameters such as ꜰ-ɴᴜᴍʙᴇʀ, ꜰɪʟᴍ ꜱᴘᴇᴇᴅ (ɪꜱᴏ) affect the image brightness.
 - If deactivated, the camera behaves like a standard camera except for Dɪꜱᴛᴏʀᴛɪᴏɴ, Mᴏᴛɪᴏɴ Bʟᴜʀ, and Dᴇᴘᴛʜ-ᴏꜰ-ꜰɪᴇʟᴅ.
- Vignetting
 - Simulation of the reduction of the image brightness in the periphery when using a real lens.
- White balance
 - Regulates the white balance.

FIG 1.39 Rendering, without Vignetting.

FIG 1.40 Rendering, with Vignetting.

FIG 1.41 Neutral White Balance.

FIG 1.42 Daylight, Optimized White Balance.

FIG 1.43 User-Defined White Balance.

- Shutter speed
 - Exposure time or shutter speed, analog to photography.
 - Values are given in s^{-1}: the higher the value, the shorter the exposure time and the darker the picture.
- Shutter offset
 - Direction of the motion blur when using a MOVIE CAM.
- Latency
 - Latency, influences motion blur when using the VIDEO CAM.
- Film speed (ISO)
 - Simulates the light sensitivity of an analog film.
 - The higher the value, the more light-sensitive the film and the lighter the image.

Bokeh Effects

The term *bokeh* describes the appearance or quality of blurred areas in a photo. It depends on the lens used; for example, blurred image areas appear softer if the aperture has many sides. The effect only applies if DEPTH OF FIELD is activated, and it is very calculation intensive.

- Blades
 - Number of blades of the aperture. If the option is deactivated, a circular blur is calculated; if activated, the blur appears polygonal, depending on the number of blades.
- Rotation (deg)
 - Alignment of blades.
- Center bias
 - Determines which areas of the blur appear lighter. Values above *0* make the outside appear brighter.
- Anisotropy
 - Simulation of amorphous lenses, the bokeh is stretched horizontally or vertically.

Sampling
- Depth of field
 - Activates the depth of field blur.

FIG 1.44 Depth of Field Blur with Near Focus.

FIG 1.45 Depth of Field Blur with Focus Far Away.

- Motion blur
 - Activates the depth of field blur.
- Subdivs
 - Determines the amount of subdivision during calculation, also referred to as *resolution*.
 - The higher the value, the higher the quality of the effects and the bigger the expenditure of time required for the calculation.

V-Ray Materials

In this section, we discuss the V-Ray materials. These are installed together with the plug-ins and are naturally optimized for V-Ray.

VRayMtl

The advantage of this material is that it has been optimized for the renderer and therefore enables it to calculate a physically correct result. It behaves physically correct with regard to absorption, reflection, and refraction of light. The material is based closely on the standard material and has similar parameters. For example, within the material you can set and change the diffuse color channel, the reflection, refraction, bump mapping, displacement mapping, and other qualities of the desired material. If possible, you should work with this material, as it has been optimized for V-Ray, and—if used in combination with V-Ray—it requires less time for rendering than other materials.

VRay2SidedMtl

The VRray2SidedMtl enables creating translucent materials. Amongst other things, it is suited very well for the representation of leaves, curtains, and paper screens.

VRayOverrideMtl

The VRayOverrideMtl enables you to override certain behaviors such as global illumination (GI), reflection, refraction, and shadow of a material independently from one another.

VRayLightMtl

With the VRayLightMtl, you can create self-luminous objects. Unlike a light source, the material does not emit photons and does not create caustics. The rendering time is shorter than if using a standard material with self-illumination, and it can be used to illuminate a scene. In combination with a VRayDirt map, you can create an ambient occlusion channel very easily. The material cannot be used if you are working with motion blur.

VRayMtlWrapper

This material applies the V-RAY OBJECT PROPERTIES to a material. You can create matte objects via materials already present in the scene.

VRayFastSSS

With this material, you can simulate the so-called subsurface scattering surface effect. The light within an object is transported on to the object. Materials such as wax or skin have this property. The VRAYFASTSSS material has a shorter rendering time and can be controlled easily.

VRayFastSSS2

This material is also used primarily for the simulation of skin, marble, and wax-like structures. It has more parameters than the VRAYFASTSSS material. You can use it for example to influence reflection and shine.

VRayBlendMtl

This material offers the option of placing several materials on top of one another, to blend them. In each case, you can choose another material for masking. The rendering time is shorter than with 3ds Max standard materials such as SHELLAC, BLEND, or COMPOSITE. This material is used for creating complex surfaces, such as car paint.

VRaySimbiontMtl

This is a special material that you can use with procedural shaders by the company Darkling Simulations. It enables you to create very complex shaders that are built completely procedurally and represented in full quality, independently from the representation distance.

V-Ray Image Sampler (Antialiasing)

"Sampling" here refers to the sampling or resolution of an image. It influences the relation between sharpness of edges and avoiding aliasing (jaggies, or stair-like lines instead of smooth lines).

Antialiasing

Antialiasing is used to reduce aliasing when converting a vector graphic into a raster picture. This method is usually achieved with smoothing of edges and occurs mostly with angled lines. In V-Ray there are two methods of antialiasing. We are going to give you a brief introduction to both.

Oversampling (Supersampling)

A rendering consists of several pixels created when converting the vector-based graphic to a raster image. The number of pixels determines

the resolution of an image and therefore its quality. Each pixel can again be subdivided into subpixels. The number of subpixels is the square of the number of subdivisions. For example, with a subdivision of 1, the pixel is divided once. There is only one subpixel. With a subdivision of 2, the pixel is divided into 4 subpixels. The finer the subdivision into several subpixels, the higher the resolution and therefore the quality of antialiasing. However, the required rendering time also increases sharply.

Undersampling

In undersampling, the opposite occurs. Pixels are not subdivided, but combined. Again, the relation is square. To keep the required rendering time low, this method is suitable for preview renderings.

V-Ray offers three antialias algorithms. Oversampling and undersampling are used differently in each. Again, we will give you a brief introduction. Choose the algorithm in the RENDER SETUP dialog box, the V-RAY tab in the V-RAY: IMAGE SAMPLER (ANTIALIASING) rollout:

- Fixed image sampler
 - Simplest antialiasing algorithm.
 - Each pixel is divided into an equal amount of subpixels.
 - The number of subpixels is always the square of the SUBDIVS value.
 - The higher the value, the better the quality.
 - The required rendering time increases rapidly with higher values.
 - Used for highly detailed scenes, high amount of motion blur, blurred reflections, detailed textures.
- Adaptive DMC
 - Number of subdivisions calculated for each individual pixel.
 - Subdivisions depend on the difference between a pixel and neighboring pixels.
 - Undersampling not possible.
 - MIN SUBDIVS: number of minimum subdivisions per pixel.
 - MAX SUBDIVS: number of maximum subdivisions per pixel.
 - CLR TRESH: influences the decision about which pixels are divided into how many subpixels; the smaller the value, the higher the quality and the required rendering time.
 - USE DMC SAMPLER TRESH: also influences the subdivision, different method.
- Adaptive subdivision
 - Complex image sampler, can also do undersampling.
 - CLR TRESH: influences the subdivision, smaller values produce a better result with longer rendering time.
 - RANDOMIZE SAMPLES: better antialiasing for approximately horizontal or vertical lines.
 - OBJECT OUTLINE: undersampling of edges for all objects.
 - NORMAL TRESH: objects in which the normals differ greatly are always subdivided more.

Summary

For scenes with sharp reflections and soft, blurry textures, always use the ADAPTIVE IMAGE SAMPLER. Scenes with highly detailed textures and lots of geometry or blurry reflections should be rendered with the ADAPTIVE DMC SAMPLER. It gives the best result with relatively short rendering times. Depending on the circumstances, the ADAPTIVE SUBDIVISION IMAGE SAMPLER may yield a lower quality, despite longer rendering times. For highly complex scenes with a great number of details and effects, apply the FIXED IMAGE SAMPLER. The required rendering time may be very long, however.

Linear Workflow (LWF)

Put simply, the linear workflow describes a method of governing the input, processing, and output of image material in 3ds Max. The monitor is not able to display an image in the same brightness as we see it in reality. Each image has a gamma correction curve in order to be displayed on the monitor in such a way that our eyes see it correctly. This is usually a gamma correction value of 2.2. Because 3ds Max works internally in a linear way—that is, with a gamma of 1.0—this correction has to be reversed. To do this, choose the following settings in 3ds Max and V-Ray.

3ds Max

Open the PREFERENCE SETTINGS dialog box (CUSTOMIZE/PREFERENCES…). Switch to the tab GAMMA AND LUT. Activate the checkbox ENABLE GAMMA/LUT CORRECTION and set GAMMA to a value of 2.2. This setting defines the monitor's gamma correction. In the BITMAP FILES group, set the INPUT GAMMA and OUTPUT GAMMA also to 2.2. This tells 3ds Max that all image data has a correction and it can reverse this. The output images (renderings) are saved once more with the gamma correction to ensure that they are displayed correctly. Also activate the two checkboxes in the group MATERIALS AND COLORS. This ensures colors and images display correctly in the material editor.

V-Ray

Open the RENDER SETUP dialog box and switch to the V-RAY tab. In the V-RAY:: COLOR MAPPING rollout, set GAMMA to 1.0.

Here, no correction is applied. In the latest V-Ray version, 1.50 SP3, you have the option to use the value 2.2 in combination with the option DON'T AFFECT COLORS (ADAPTATION ONLY). V-Ray is already working with the corrected brightness internally. The correction is not yet saved into the picture, however, but used only for calculating the sampling. This produces a better quality, as image areas that are too dark are lightened by gamma correction.

In order to have the V-Ray frame buffer display the correct brightness, you must activate the option DISPLAY COLORS IN sRGB SPACE.

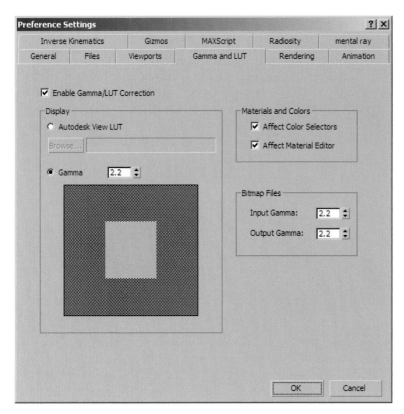

FIG 1.46 Render Setup Dialog Box, Gamma, and LUT.

FIG 1.47 Render Setup, VRay:: Color Mapping, Gamma 1.0.

FIG 1.48 Render Setup, V-Ray: Color Mapping, Gamma 2.2, Don't Affect Colors (Adaptation Only).

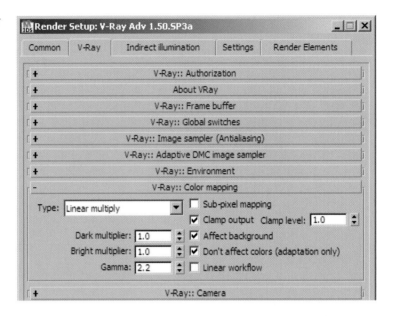

FIG 1.49 V-Ray Frame Buffer, without Gamma Correction.

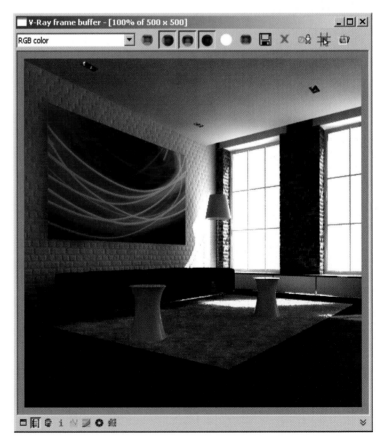

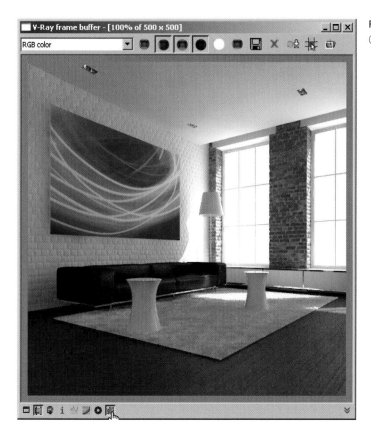

FIG 1.50 V-Ray Frame Buffer, with Gamma Correction.

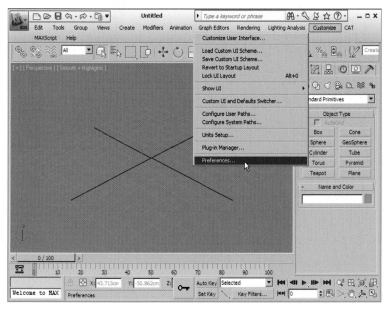

FIG 1.51 Opening the Default Settings of 3D Studio Max.

FIG 1.52 Activating and Setting the Correct Gamma Value.

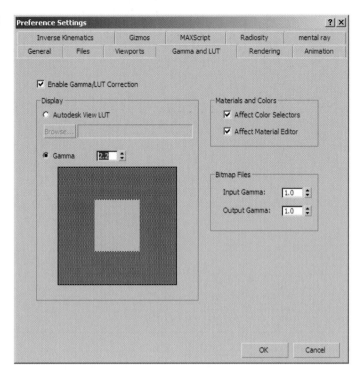

FIG 1.53 Setting the Right Gamma Values for Input and Output of Image Files In 3D Studio Max and the Color Corrections for the Material Editor.

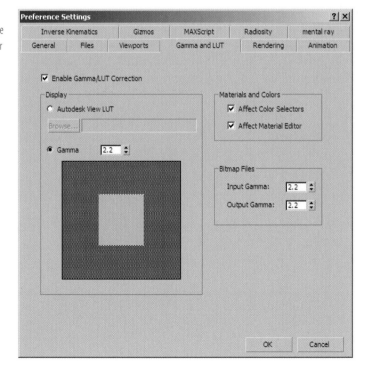

FIG 1.54 Material Editor before Gamma Correction.

FIG 1.55 Material Editor after Gamma Correction.

About the CD Included with This Book

Directory Structure

Before you start reading the next chapter, please take the time to read the following comments. All files in the following chapters can be found in the corresponding subdirectory to that chapter—for example, *chapters/ch_02* for Chapter 2. This directory contains the 3ds Max files. The first file (*ch_02_01.max*) is the introduction to the chapter, and the second file (*ch_02_02.max*) shows the image at the end of the chapter, after applying the changes discussed in the chapter. You can use this file to quickly refer to a material, for example, or if you want to try something without having to work your way through the entire chapter first. Each chapter directory contains subdirectories for textures, AutoCAD files (*dwg*), and so on. **Figure 1.56** shows the directory structure of Chapter 2.

FIG 1.56 Directory Structure of Chapter 2.

Units

Our AutoCAD and 3ds Max files are all measured in centimeters (cm). This scale lends itself for architectural visualization. All objects or light sources are covered well without an excessive amount of zeros before or after the decimal point. The 3ds Max system unit is set to centimeters as well. If you are using other units, 3ds Max will ask you when opening our files if you want to keep the units or convert to your settings. Please make sure that you adopt the units of measurement from our file to avoid conversion errors. In the FILE LOAD: UNITS MISMATCH dialog box, choose the option ADOPT THE FILE UNIT'S SCALE. Otherwise, you can end up with wrong values, such as for the intensity of light sources.

FIG 1.57 Open File, Adopt File's Unit Scale.

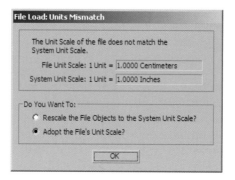

You can view and change your settings in the UNITS SETUP dialog box (CUSTOMIZE/UNITS SETUP…). Make sure that the unit for lighting is also set correctly: under LIGHTING UNITS, you should have the unit INTERNATIONAL selected. You can change the system unit by clicking on the SYSTEM UNIT SETUP button in the UNITS SETUP dialog box.

FIG 1.58 Units Setup Dialog Box, Change Units.

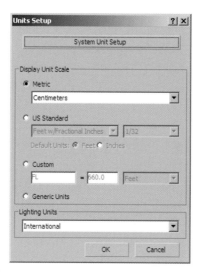

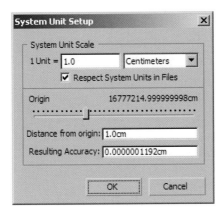

FIG 1.59 System Unit Setup Dialog Box, Change System Units.

Gamma Correction

To be able to work correctly with 3ds Max, you should generally adopt the settings described in section 1.3.11. Again, 3ds Max will ask you if other settings should be used. Adopt the settings from our file when loading it by choosing the option ADOPT THE FILE'S GAMMA AND LUT SETTINGS in the FILE LOAD: GAMMA & LUT SETTINGS MISMATCH dialog box.

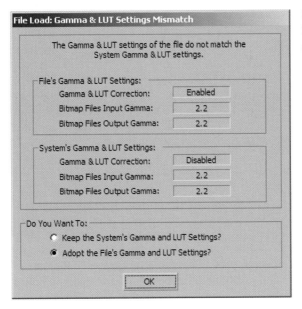

FIG 1.60 File Load: Gamma & LUT Settings Mismatch Dialog Box, Adopt File's Gamma Correction.

Adapt Paths (Asset Tracking)

In our 3ds Max files, all textures, IES profiles, AutoCAD files, and so on are mostly linked. You can therefore copy the CD's folder structure to any folder on your hard drive and 3ds Max should be able to find all used files.

We recommend that you adapt the links to your file system. Open the ASSET TRACKING dialog box (3DS/MANAGE/ASSET TRACKING). Here you can see all file links in the scene. You can change the paths by right-clicking on an entry and choosing SET PATH.... Even if 3ds Max displays an error message when opening a file, telling you that a file was not found, you can use this dialog box to assign the correct path to that file.

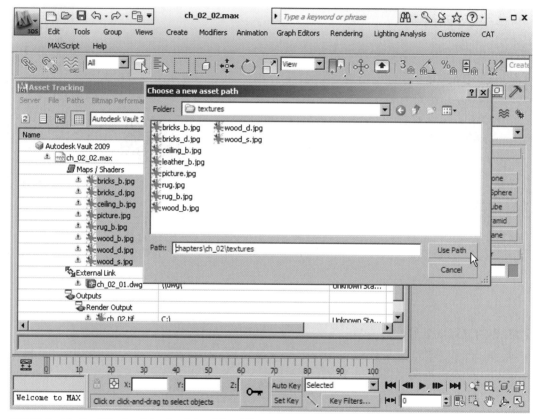

FIG 1.61 Asset Tracking Dialog Box, Assign New Path to Selected Files.

Versions Used

This book refers to the current program versions, 3ds Max 2010 or 3ds Max Design 2010 and V-Ray Advanced 1.50.SP3a. The files included on the CD are also in the most current format. If you are still using older versions of the programs, you can download a trial version of the current products from each manufacturer's web site. You may need to register to do so.

- Autodesk (http://www.autodesk.com)
- Chaos Group (http://www.chaosgroup.com)

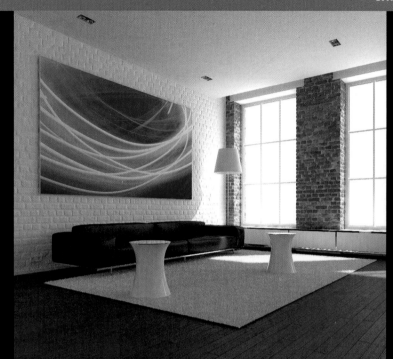

Loft Apartment in Daylight

Introduction to Scene

A classical loft apartment provides the setting for this daylight scene. The floor is covered by dark floorboards, the outer walls are exposed brickwork, and the internal walls are painted white. The large industrial windows let a lot of light into the room.

Preparing the Scene

We will link an AutoCAD file using the FILE LINK MANAGER and insert the furniture into the room with the MERGE function. First we need to create a preset for linking the AutoCAD file.

Preset for File Link Manager

Start 3ds Max and open the File Link Manager (3DS/REFERENCES/FILE LINK MANAGER). In this dialog box, go to the PRESETS tab and click on the NEW...

Architectural Rendering with 3ds Max and V-Ray. DOI: 10.1016/B978-0-240-81477-3.00006-5

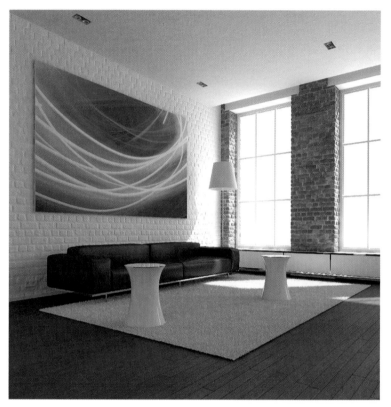

FIG 2.1 Loft Apartment.

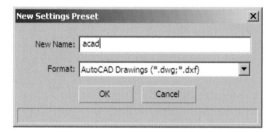

FIG 2.2 File Link Manager, New Preset.

button. Enter the name *acad*. Confirm with Oĸ, then select the new preset from the list and click on Mᴏᴅɪꜰʏ....

In the resulting Fɪʟᴇ Lɪɴᴋ Sᴇᴛᴛɪɴɢs: DWG Fɪʟᴇs dialog box, go to the Bᴀsɪᴄ tab and increase the value for Cᴜʀᴠᴇ Sᴛᴇᴘs to *16* and the value for Mᴀxɪᴍᴜᴍ Sᴜʀꜰᴀᴄᴇ Dᴇᴠɪᴀᴛɪᴏɴ ꜰᴏʀ 3D Sᴏʟɪᴅs to *0.1 cm*. This increases the accuracy when reading the AutoCAD geometry, which affects (above all) curves. Deactivate all the checkboxes in the Iɴᴄʟᴜᴅᴇ group. You want only the geometry to be included.

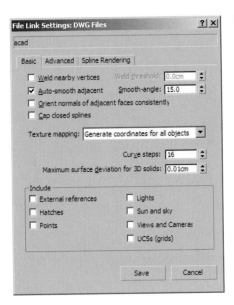

FIG 2.3 File Link Manager, Preset, Basic.

Switch to the ADVANCED tab. Set the drop-down menu DERIVE AUTOCAD PRIMITIVES BY to LAYER, BLOCKS AS NODE HIERARCHY. This specifies that the layer structure of the AutoCAD file is adopted and the objects are arranged according to this hierarchy. The great advantage is that you can assign materials and modifiers to a whole layer. If you change anything in the AutoCAD model's geometry, you can update the file in 3ds Max and the assigned materials are maintained. To save the preset, click on SAVE.

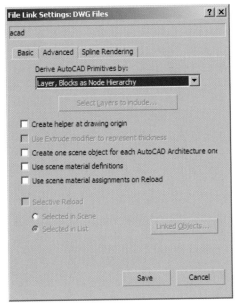

FIG 2.4 File Link Manager, Preset, Advanced.

Open File

Go to the book CD directory *Chapter\Ch02* and open the file *ch02_01.max*. In the main menu, choose the menu 3DS/REFERENCES and open the FILE LINK MANAGER. Link to the file *ch02_01.dwg* in the *dwg* subdirectory. Use the PRESET *acad* you created previously.

FIG 2.5 File Link Manager, Link File.

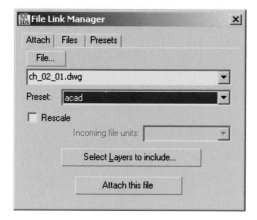

Load the interior for the scene with the command 3DS/MERGE. From the subdirectory merge, choose the file *ch02_mg.max*. Select all objects in the MERGE dialog box. Use the VIEWPORTS and the LAYER MANAGER (3DS/MANAGE LAYERS...) to familiarize yourself with the scene.

FIG 2.6 Merge, Select All.

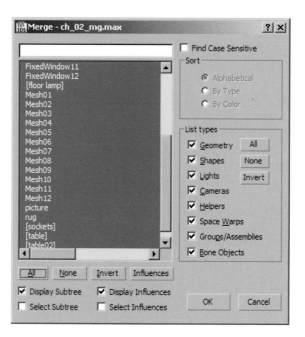

Adapt Viewport and Image Output

Activate the Perspective Viewport. Now right-click on Perspective and activate the option Show Safe Frames (Shift-F). The visible image section is now marked with a yellow rectangle. Open the Render Setup (Rendering/Render Setup...) and set the Output Size to a square image format *500* by *500* pixels.

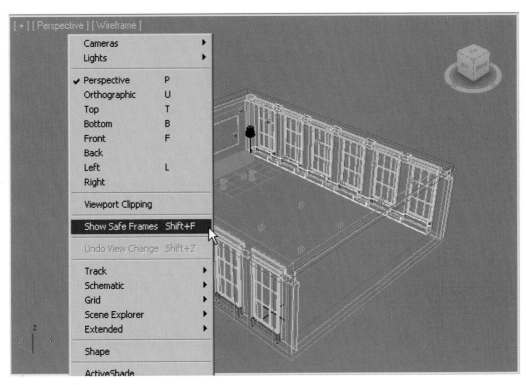

FIG 2.7 Show Safe Frames.

Camera Setup

Change to the Top Viewport: in the Command Panel, under Create/Camera, create a VRayPhysicalCam. This gives you the option of using exposure parameters, such as exposure time or aperture, as analogs of photography. Now you can select your camera and set the Focal Length (mm) to 35 mm (also in the Command Panel, in the Modify tab). This enlarges the displayed image selection, which is often useful for indoor renderings, where the camera is usually positioned very close to the objects to be depicted, but at the same time you want to show a lot of the room. Shift the camera left, below the rug. Move the Target to about the top-right corner of the model. In the Perspective Viewport, select the camera by pressing the C key. Adapt the height of camera and target as well. Set the camera to a height of about 80 cm and move that target so that a little bit of floor remains visible in front of the rug in the lower part of the picture; see **Figure 2.8**.

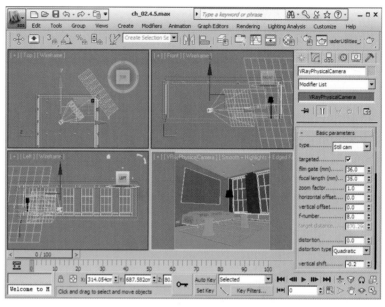

FIG 2.8 Create Camera.

To finish, apply the camera correction to remove perspective distortion. Select your camera, then go to COMMAND PANEL/MODIFY and click on the GUESS VERTICAL SHIFT button. The value is calculated automatically—you can check the result in the CAMERA VIEWPORT. If you change the camera position, you need to apply the correction again.

FIG 2.9 Camera without Camera Correction.

FIG 2.10 Camera with Camera Correction.

Basic Settings for Texturing

Before we can texture the scene, we need to make some preparations in order to reduce rendering time, to check geometry for errors, and to enable us to check the textures in neutral light.

Create Test Material

Open the MATERIAL EDITOR. In the first slot, create a new VRayMtl and name it *Test_Material*. In the DIFFUSE CHANNEL, set all the color values for RGB to *230*.

FIG 2.11 Test Material.

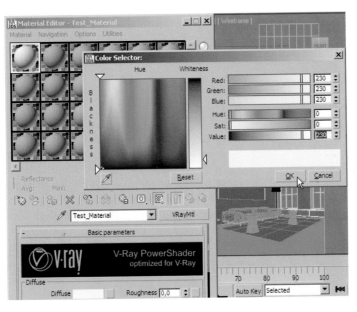

This corresponds to a neutral white. In the LAYER MANAGER (TOOLS/MANAGE LAYERS…), select all layers and assign the test material to them.

To save time in the following section, switch the layer *01_glass* to not visible (HIDE). The calculation of glass is very complicated; therefore, we will activate it only when we are ready for fine tuning. Now all objects in the scene have a uniform material. This way, it is easier to assess newly created materials. Also, it prevents unwanted color bleeding and reflections.

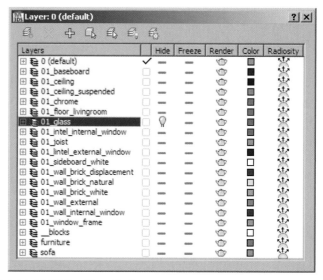

FIG 2.12 Switch Off Visibility of Layer 01_Glass.

V-Ray Basic Settings

All the following parameters are set in the RENDER SETUP (RENDERING/RENDER SETUP…). Select the V-RAY tab and open the V-RAY::FRAME BUFFER rollout. Check the box ENABLE BUILT-IN FRAME BUFFER. This replaces the default 3ds Max Frame Buffer. Now you have access to V-Ray-specific functions, such as the sRGB mode for gamma correction. We will get back to this later.

In the V-RAY:: GLOBAL SWITCHES rollout, deactivate the HIDDEN LIGHTS to make sure that invisible light sources are not included in the light calculation. In the DEFAULT LIGHTS drop-down menu, the option OFF WITH GI should be selected. The default light is used only if no Global Illumination is used.

Now change to the V-RAY:: IMAGE SAMPLER (ANTIALIASING) rollout. Select the option FIXED in the IMAGE SAMPLER and deactivate the ANTIALIASING FILTER. Leave all other settings at the default.

Set the value for SUBDIVS in the V-RAY:: FIXED IMAGE SAMPLER rollout to *1*.

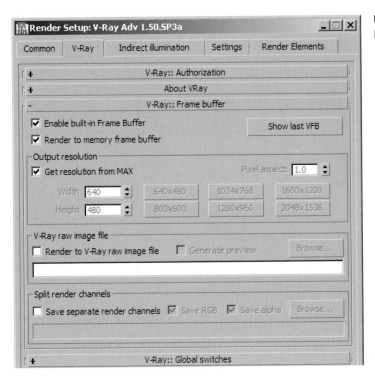

FIG 2.13 Render Setup, V-Ray::
Frame Buffer.

FIG 2.14 Render Setup, V-Ray::
Global Switches.

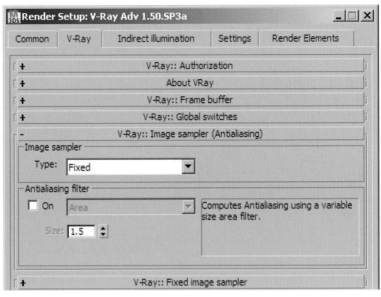

FIG 2.15 Render Setup, V-Ray:: Image Sampler (Antialiasing).

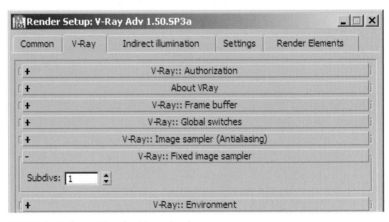

FIG 2.16 Render Setup, V-Ray:: Fixed Image Sampler.

In the next step, we will determine the settings for indirect illumination, that is, the light calculation itself. First we need to activate it. Choose the Indirect Illumination tab and activate the On checkbox in the V-Ray:: Indirect Illumination (GI) rollout. As described in Chapter 1, the light calculation in V-Ray is determined by the Primary Bounces and Secondary Bounces. Taking an acceptable rendering time into consideration, the best result will be achieved by a combination of Irradiance Map (Primary Bounces) and Light Cache (Secondary Bounces). Choose both.

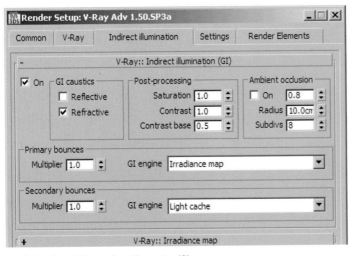

FIG 2.17 Render Setup, V-Ray:: Indirect Illumination (GI).

Open the V-Ray:: Irradiance Map rollout. In the Current Preset drop-down menu, choose Very Low then Custom. We want to reduce the accuracy even more. Under Basic Parameters, set the value for Max rate to -4. Reduce the Hsph. Subdivs to 30. To get an impression during your rendering procedure of what your result will look like, activate the checkbox Show calc. Phase under Options. This enables you to stop the rendering any time if an error occurs.

FIG 2.18 Render-Setup, V-Ray:: Irradiance Map.

In the last step, go to the V-Ray:: Light cache rollout and set Subdivs to a value of *300*. To make the best possible use of your computer's abilities, set the Number of passes to twice the number of your CPUs, such as *8* for a quad-core machine.

> 📖 **Tip:** Make sure that the Show calc phase checkbox is activated to get feedback.

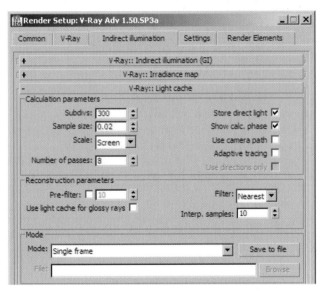

FIG 2.19 V-Ray:: Light Cache.

VRayLight Setup

To illuminate the scene evenly, it is a good idea to choose a light source that emits only diffuse light. Create a VRayLight in the Top Viewport (Command Panel/Create/Lights/V-Ray/VRayLight). You need to determine the type of the light source in the Modify tab: choose Dome from the Type drop-down menu. For Options, activate the Invisible checkbox. Now the light source is not visible in the rendering and the light color is determined only by the Color value. Now render an image. The V-Ray Frame Buffer opens, and as you can see, the result looks somewhat dark. This takes us back to the linear workflow. Activate the Display Colors in SRGB Space icon in the status bar of the frame buffer. V-Ray now applies gamma correction and the image appears lighter.

Now we still need to adapt the Camera Viewport, as 3ds Max is illuminating the scene with the new light source. Right-click the display mode (Smooth+ Highlights), then go to Lighting and Shadows and choose the Illuminate with Default Lights option. The Viewport is now evenly lit again.

FIG 2.20 VRayLight (Dome) and V-Ray Frame Buffer.

FIG 2.21 Camera Viewport, Illuminate with Default Lights.

Create and Assign Textures

A rendering stands or falls according to the degree of care taken in texturing. We work exclusively with the V-Ray materials to achieve the best possible results. Little tricks help us represent the result even more realistically. We create the textures step by step in the MATERIAL EDITOR, select the objects in the scene, and assign the material. Choose an empty slot for each new texture and assign it a name. It's very important to keep track of things!

Brick, White Paintwork

Let's first turn our attention to the outside walls. The building is a former factory; therefore, the outside walls are exposed brickwork.

- Open the MATERIAL EDITOR and name an empty slot *brick_white*.

Click on the button to the right of the name field and create a VRAYMTL in the MATERIAL/MAP BROWSER. This is the standard V-Ray material.

- DIFFUSE CHANNEL

Change the color value to a Gray of *230*. This corresponds to a neutral white, as mentioned previously for the test material.

FIG 2.22 Brick_White, Overview.

- BUMP CHANNEL

The MAPS rollout of the MATERIAL EDITOR lists all map channels. Click on the NONE button in the BUMP CHANNEL. Choose BITMAP and use the image *brick_b.jpg* in *chapters\ch02\textures* of the book CD. This is a grayscale image, and bump-mapping makes lighter colors appear raised.

In the MATERIAL EDITOR, activate the option SHOW STANDARD MAP IN VIEWPORT for the current material. Now the map is displayed in the VIEWPORT, instead of the DIFFUSE color. This is generally recommended for any newly created material, as it lets you check the mapping. Depending on your computer's hardware specs, handling the scene may be difficult. If you have many materials in one scene, you may need to deactivate the display again.

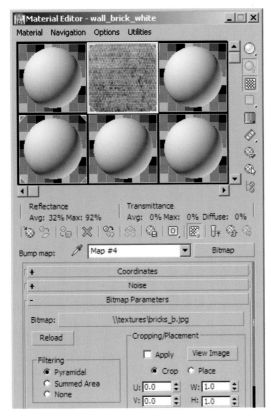

FIG 2.23 Brick_White, Bump Map.

- Assign material

Open the LAYER MANAGER and select the layer *01_wall_brick_white*. All objects within the layer are now selected. In the MATERIAL EDITOR, assign the new material with MATERIAL/ASSIGN TO SELECTION.

- UVW Mapping

To project the material onto the wall correctly, you must assign UVW coordinates to the wall with the UVW Map MODIFIER. Select the layer *01_wall_brick_white* in the LAYER MANAGER again. Under COMMAND PANEL/MODIFY, pull down the MODIFIER LIST and choose the UVW MAP MODIFIER. Change the

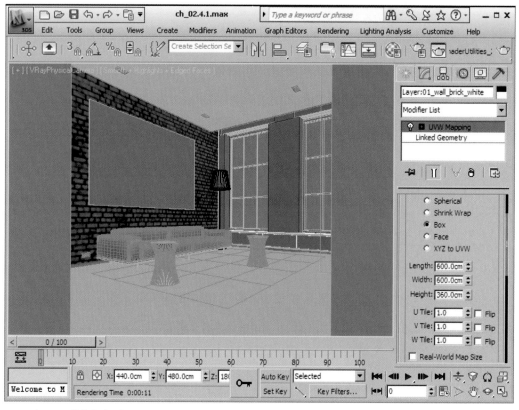

FIG 2.24 Layer 01_Wall_Brick_White, UVW Map.

mapping type in BOX. The material is now projected three-dimensionally onto the object. The values for LENGTH, WIDTH, and HEIGHT always depend on the material—in our case, on the picture we use. If you look at our picture of the bump texture, you will notice that it is very large. You can estimate the dimensions of the texture in the scene from looking at the brick size. You also need to take into account the picture's aspect ratio, to make sure that the texture does not get distorted. Set LENGTH and WIDTH to *600 cm* and HEIGHT to *360 cm*. Render the picture to test the material.

Brick, Exposed Brickwork

The material of the exposed brickwork is the same as the one used before. Additionally, we place an image for the map color into the DIFFUSE CHANNEL.

- Create a new material in the MATERIAL EDITOR and name it *brick_natural*.
- DIFFUSE CHANNEL

Place the image *brick_d.jpg* from the *Texture* folder of the chapter into the DIFFUSE CHANNEL, using a BITMAP. The image has of course the same size as the bump texture. Here's something to watch out for: in the BITMAP PARAMETERS

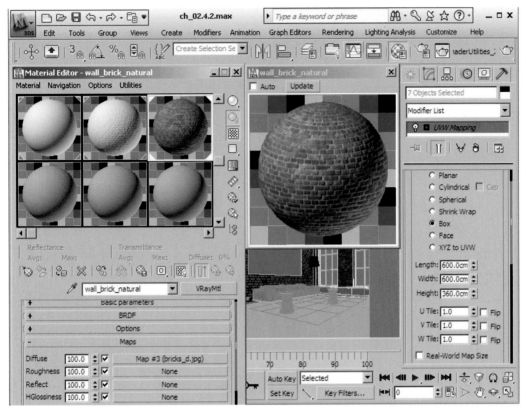

FIG 2.25 Brick_Natural, Overview.

rollout, the default setting of FILTERING is PYRAMIDAL. The image will be blurred and details will be lost. To keep the details intact and avoid perspective washout, choose SUMMED AREA. This is recommended for almost any texture based on image material.

- BUMP CHANNEL

Allocate the BUMP CHANNEL analog to the texture *brick_white*.

- Assign material, UVW mapping

In the LAYER MANAGER, assign the material again to the layers *01_wall_brick_natural*, *01_wall_internal_window*, *01_wall_brick_displacement* and *01_wall_external*. Apply the UVW MAP modifier to the layers. As the images used have the same size, the values are again identical.

Floor, Parquet

We will cover the floor with dark, solid parquet flooring. Now reflection comes into play and the time required for rendering the image increases noticeably.

FIG 2.26 Wood_D.jpg, Output Amount.

- Create a new material. Name it *floor_parquet*.
- Diffuse channel

Load the image *wood_d.jpg* into the Diffuse channel as Bitmap. This is a very dark image, so we will lighten it a little bit. Open the Output rollout. Increase Output Amount to *2.2*. You can vary this setting later if the result is too light or too dark.

- Reflection channel

The parquet flooring reflects unevenly, as do many structured materials. Consequently, we do not use a fixed gray value for the reflection

FIG 2.27 Floor_Parquet, Overview.

intensity, but a bitmap with different gray values. We provide the file *wood_s.jpg* for this purpose. As with the *bump map*, the same advice applies in this case: the lighter the gray value, the bigger the effect (in this case, the reflection). This time we use the Output Amount to reduce the reflection. Enter a value of *0.1*. Go back to the top layer of the material. In the Material Editor preview window, you can now see strong highlights on the wood. Reduce the value Refl. Glossiness to *0.65* to make the reflection softer and more natural. Increase the Subdivs in the field below to *16*. The softer the reflection, the higher the values need to be in order to avoid unwanted grain in the picture. You do need to think carefully about the value you decide to set, however, as this affects the required rendering time greatly. A value of *16* should be okay for now.

- Bump channel

Of course we again use a Bitmap texture. Use the file *wood_b.jpg* from the subdirectory *textures*. Because of the fine joints in this texture, it is especially important to set Filtering to Summed Area.

- Assign material, UVW mapping

Assign the material to the layer *01_floor_livingroom*. Apply the UVW Map modifier with these settings: Length *200 cm*, Width *400 cm*. Choose Planar as the mapping type.

Picture

Now we turn our attention to the nondescript rectangle above the couch. We want to turn it into a work of art that makes the large white wall look less austere. We will base it on an abstract photograph by artist Anna-Dorothee Arnold. The main focus is on assigning the material. We will use a Multi/Sub-Object material and give the object more vividness with a little trick.

- Prepare *Picture* object, assign material

In the Top Viewport, select the rectangle above the couch (*picture*) and isolate it by right-clicking on the object and choosing Isolate Selection from the resulting menu. Alternatively, you can press Alt + Q. First press the Z key to center the picture in every viewport. In the Modify tab of the Command Panel you can see that this is a Box object. But we want to texture the individual faces differently by working with Material ID. The Edit Poly modifier is our first choice in this case. Apply it to the object. If you expand the modifier, it offers you five different options for altering the object. We want to edit faces, so Polygon is the best option. First, select all areas. In the Polygon: Material IDs rollout, enter *2* for Set ID. Now select only the object's polygon that faces the room and assign the ID *1* to this polygon.

FIG 2.28 Picture, Isolated Selection, Assign Material ID 2 to All Polygons.

FIG 2.29 Picture, Assign Material ID 1 to Front-Facing Polygon.

- Multi/Sub-Object material

Name a free material slot *picture_multi*. For the material, choose Multi/Sub-Object. As you can see, there is a list of ten currently unassigned materials. They have an ID, Name (description), and a material slot. Use the Set Number button to limit the number to *2*.

Now we are going to create the two materials:

- Assign VRayMtl to the first slot. Name it *picture_painting*. Place a Bitmap texture into the Diffuse channel and select the file *picture.jpg*.
- Name the second slot of the Multi/Sub-material *picture_painting_back*. As new material, choose VRayOverrideMtl. This enables overriding properties such as global illumination (GI) color or reflection color with new materials. For the Base Material, create a VRayMtl with a Gray value of 230 in the Diffuse channel. For the GI Material, also create a VRayMtl, but set the RGB value in the Diffuse channel to 0, 0, 0.

We aim to achieve two things with this material. The picture is displayed on only the front of the picture frame, so the sides and back are white.

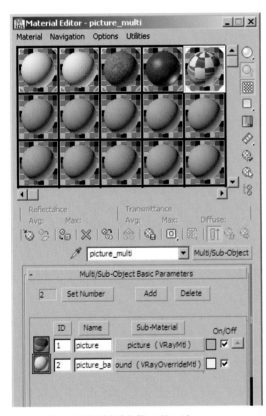

FIG 2.30 Picture_Multi, Multi/Sub-Object Material.

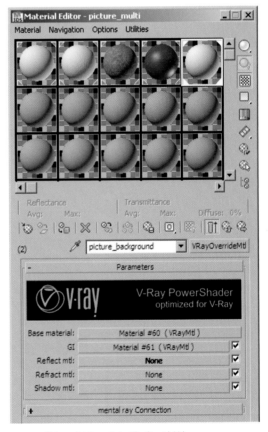

FIG 2.31 Picture_Painting_Back, VRayOverrideMtl.

FIG 2.32 Rendering with Picture.

But these white areas bleed black during the calculation of the indirect illumination. This darkens the wall area around the picture and the picture frame stands out more. That seems like a lot of effort for such a small effect, but it is these sorts of details that make a good rendering.

White Material, Matte

Now we will do something less spectacular, just for a change. There are some objects in our scene, such as window frames and skirting boards, to which we will assign a simple white material. These do not need any reflection.

- Name the new material *white_matte*. Create a VRayMtl and set the Gray value to *230* in the Diffuse channel.
- Assign material

FIG 2.33 White_Matte, Assign to Lampshade.

In the Layer Manager, select the following layers and assign the material.

- 01_ceiling
- 01_window_frame
- 01_baseboard
- 01_joist
- 01_lintel_internal_window
- 01_lintel_external_window

Now select the object *floor lamp* in one of the viewports. This object is actually a group containing several objects with different materials. We want to assign the current material to the *lampshade*. Open the group with Group/Open. Select the *lampshade* and assign the material. Close the group again to avoid accidentally changing other objects in it.

White Material, Reflecting

For other objects, we also need white material, but this time we want it to reflect—for example, shiny plastic surfaces or varnished wood. The Reflection channel has something special to offer.

- In a new slot, create the VRayMtl material *white_reflecting*, again with a Gray value of *230* in the Diffuse channel.
- Reflection channel

A lighter shade of gray in the Reflection channel would produce a nice reflection. But we want the effect to be a little more realistic. Next time you get the chance, have closer look at a cue ball or a white porcelain cup. The reflection on the curved surface increases towards the edges, whereas a small area in focus has almost no reflection. This is particularly relevant for the two end tables. To achieve this effect, select Falloff as map for the Reflection channel. It enables falloff, in this case of the reflection, via a black-and-white gradient. To limit the effect even more to the object edges, look at the curve in the Mix Curve rollout.

FIG 2.34 Mix Curve, Bezier-Corner.

The horizontal axis indicates the gradient from black to white; the vertical axis, the white content. At the moment, the gradient is linear, defined by two points at bottom left and top right. Right-click on the bottom-left point

FIG 2.35 Mix Curve, Adapted Curve.

and change the point's behavior to BEZIER-CORNER. Now drag the new control point to the bottom-right corner. The black content—that is, the areas without reflection—are now bigger, and the material reflects only on the edges, just as we wanted.

• Assign material

In the LAYER MANAGER, select the layer *01_sideboard_white* (the sideboards below the windows) and assign the material. Select the two *sockets* to the left of the couch in any Viewport and also the two *tables*. Assign the material to these objects as well.

FIG 2.36 White_Reflecting, Material Editor View.

Chrome

We also have some pretty chrome objects in our scene. These reflect their surroundings almost entirely and create impressive light reflections. Here we need a SHELLAC material to overlay the reflection with a soft highlight.

• Create a new VRAYMTL called *Chrome*.
• DIFFUSE CHANNEL

Change the color swatch to *black*.

• REFLECTION CHANNEL

Create a FALLOFF map in the REFLECTION CHANNEL. You need to adapt the curve in the MIX CURVE rollout. Drag the left point upwards, to a value of about *0.6*. In frontal view, the object now has almost no reflection, but towards the edges of the sphere in the MATERIAL EDITOR, it increases. Compare your settings to those in **Figure 2.38**.

FIG 2.37 Material Editor, Chrome, Overview.

FIG 2.38 Falloff Map, Adapted Curve.

• Shellac material

Create the Shellac material using the VRAYMTL and change the SHELLAC COLOR BLEND value to 100. In the SHADER BASIC PARAMETERS rollout, choose ANISOTROPIC. The following settings refer to the ANISOTROPIC BASIC PARAMETERS rollout. Change the color in the Diffuse swatch to *black*. Enter the value *60* for SPECULAR LEVEL, *15* for GLOSSINESS, and *90* for ANISOTROPY.

FIG 2.39 Chrome, Shellac Material, Overview.

FIG 2.40 Chrome, Shellac Material Settings.

- Assign material

In the LAYER MANAGER, assign the material to the layer *01_chrome* (frame of sideboards). Also assign the material to the following objects in the scene:

- ceiling lights
- floor lamp

Isolate the group *floor lamp* and open it. Assign the material to all objects except for the lampshade.

- Couch base

Open the group *couch* and assign the chrome to the group *couch_frame*.

- Tables

Again, only one object of the group *table* needs to have the material *chrome* assigned to it. Here we use a SCENE EXPLORER. Open a new SCENE

FIG 2.41 Scene Explorer, Limit Selection, Select Group Table.

EXPLORER (TOOLS/NEWSCENEEXPLORER). A SCENE EXPLORER enables the handling of practically any objects in your scene. It can, for example, tell you whether an object has a material assigned to it (HAS MATERIAL) and is very adaptable to your particular needs. You can create more than one SCENE EXPLORER. Using the icons in the main menu bar, you can limit the selection of displayed objects. Choose only DISPLAY GEOMETRY and DISPLAY GROUPS.

In the selection list, activate the group *table*. Right-click on the selection and choose GROUPS/OPEN GROUP from the list. Now you can add your objects to the group *table*. Highlight the object *table_top* and assign the material *chrome*. Now you can close the group. Do the same with the group *table02*.

FIG 2.42 Scene Explorer, Open Group Table.

FIG 2.43 Scene Explorer, Select Object Table_Top.

Leather

The couch should have a black leather covering. Once the sunlight is shining onto the couch, we want to achieve a nice soft sheen.

- Create a new VRayMtl and name it *leather*.
- Diffuse channel

Set the Gray in the Diffuse channel to *10*. Just as with white materials, we do not set black surfaces to pure black.

- Reflection channel

Leather is also a reflecting material, but has a soft reflection. Assign a Gray value of *8* to the amount of the reflection. Reduce the value for Refl.

FIG 2.44 Leather, Overview.

71

GLOSSINESS to *0.8* to achieve a softer reflection. Increase SUBDIVS to *32*. Now we want to add a slightly harder, more precise highlight. Deactivate the box with the L to the right of HILIGHT GLOSSINESS. This removes the link between HILIGHT GLOSSINESS and REFL. GLOSSINESS; you can now enter separate settings for each. Set HILIGHT GLOSSINESS to *0.75* and look at the change in the material preview.

• Assign material

Open the group *couch* and assign leather to the group *couch_leather*.

Ceiling, Textured Plaster

The ceiling has a textured plaster finish. We will create a white material, again with a *bump map*.

• Name the new material *ceiling*. Again, choose a VRAYMTL.
• DIFFUSE CHANNEL

Enter a Gray value of *230*.

• BUMP CHANNEL

Place a Bitmap texture into the BUMP CHANNEL. Choose the file *ceiling_b.jpg* from the folder *chapters/ch_02/textures*.

• Assign material, UVW mapping

In the LAYER MANAGER, select the layer *01_ceiling_suspended* and assign the material. We need to place a modifier UVW MAP onto the layer *ceiling*, as we are using an image in the bump texture again. Choose BOX as the mapping method. Set LENGTH, WIDTH, and HEIGHT to *150 cm*.

Rug

Next, let's focus on the plane below the couch. A large flokati rug perfects the room composition and creates a cozy atmosphere. First, we will use a *bump map* to make the rug look more 3D, and then we will apply the displacement modifier.

• Create a new VRAYMTL and name it *rug*.
• DIFFUSE CHANNEL

Enter a Gray value of *230*.

• BUMP CHANNEL

Create a BITMAP texture and select the image *rug_b.jpg*.

• Assign material, UVW mapping

Select the object *rug* in the scene and assign the material. Now apply the UVW MAPPING modifier. Leave the mapping method set to PLANAR and set a value of *50 cm* for LENGTH and WIDTH.

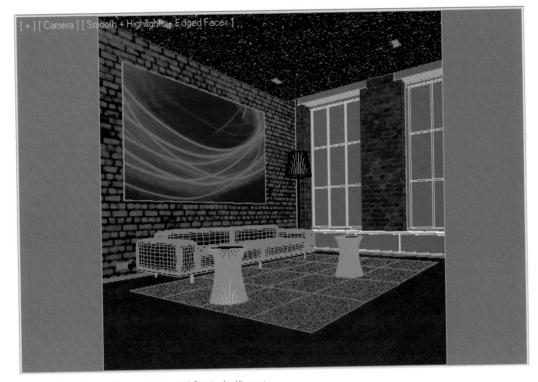

FIG 2.45 Bump Structure Display of Ceiling and Rug in the Viewport.

Glass

Now we'll create the glass for the window panes.

- Create a new VRayMtl and name it *glass*.
- Diffuse channel

Set the Diffuse channel to a pure white.

- Reflection channel

For the reflection, change the gray value to white. The Fresnel reflection is relevant for glass. Activate the Fresnel Reflections checkbox. The Fresnel effect is determined by the Fresnel IOR value. The default setting of *1.6* corresponds to the transition from air to glass, which is what we want here. You can adjust this setting to achieve different reflections. But that is not necessary in our case.

- Refraction channel

Enter again a value of *255*. Ensure that the Affect Shadows checkbox is activated, which allows light to pass through. Also select the Color+Alpha option under Affect Channels to make sure that it is taken into account during the alpha channel calculation.

FIG 2.46 Glass, Reflection Channel.

FIG 2.46 Glass, Reflection Channel.

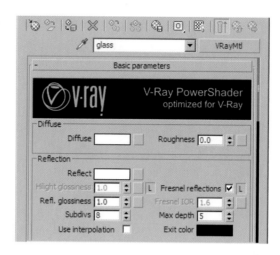

FIG 2.47 Glass, Refraction Channel.

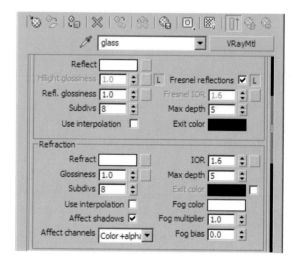

- Assign material

In the LAYER MANAGER, make the layer *01_glass* visible again. Select the layer and assign the material.

Light Setup

Now that we have assigned a material to every object in the scene, we can get into the light setup. We are going to use only the V-Ray sunlight.

Sunlight

Before setting up the new light, delete the DOME light that was used until now. The V-Ray sunlight (VRaySUN) is a directional light; it has a light source

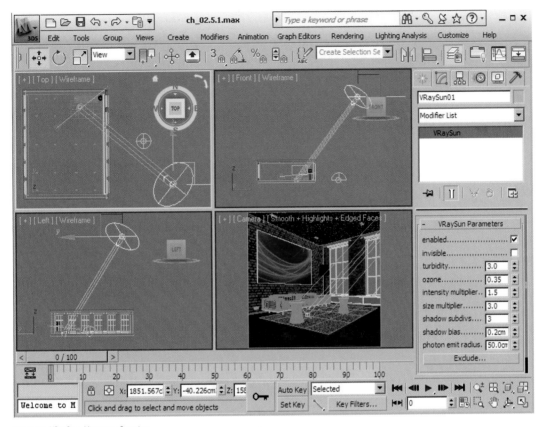

FIG 2.48 VRaySun, Viewport Overview.

and a target. A texture for the surrounding area—the sky, so to speak—is created automatically. You can change settings such as tint or atmospheric pollution. Create the VRaySun in the Top Viewport (Command Panel/Create/Lights/ V-Ray). Place the target on the rug and drag the light source to the bottom right. Adjust the direction of the light so that the sunlight falls into the room diagonally from the right. There should be direct sunlight on the rug, about a third of the couch and the wall. Compare your scene to that in **Figure 2.48.**

V-Ray Rendering Settings

We have nearly achieved our aim. Next, we will work our way step by step through the crucial V-Ray settings. Now our materials will really come into their own. But we also have to strike a careful balance between rendering time and quality of the final result. Our final result takes about 25 minutes at a resolution of 2000 × 2000 pixels on a quad-core computer with 4 GB RAM. If you use a dual-core computer, the required time will double. We

recommend that you experiment with the settings described in the following sections.

V-Ray

Open the RENDER SETUP dialog box and switch to the V-RAY tab. The following bullet points focus on a rollout each:

- V-Ray:: Image sampler (Antialiasing)

Choose ADAPTIVE DMC under TYPE and reactivate the ANTIALIASING FILTER. Here you should choose BLACKMAN.

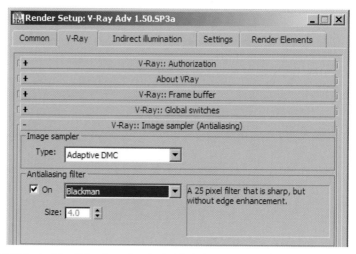

FIG 2.49 Render Setup, V-Ray:: Image Sampler (Antialiasing).

- V-Ray:: Adaptive DMC image sampler

Set MIN SUBDIVS to *4* and MAX SUBDIVS to *10*.

FIG 2.50 Render Setup, V-Ray:: Adaptive DMC Image Sampler.

Indirect Illumination

Switch to the INDIRECT ILLUMINATION tab.

* V-Ray:: Irradiance map

Choose the MEDIUM setting under CURRENT PRESETS. Under BASIC PARAMETERS, increase the HSPH. SUBDIVS to *50*.

FIG 2.51 Render Setup, V-Ray:: Irradiance Map.

* V-Ray:: Light cache

Change the SUBDIVS setting to *2500* and the SAMPLE SIZE to *0.01*. Activate the USE LIGHT CACHE FOR GLOSSY RAYS checkbox to ensure that soft reflections are calculated in this process.

FIG 2.52 Render Setup, V-Ray:: Light Cache.

Now render the image at a resolution of 2500 × 2500 pixels. Keep an eye on the required rendering time. You may need to lower the settings a bit. Try the Low preset in the Irradiance map or reduce the Adaptive DMC image sampler values, perhaps to 2 and 6.

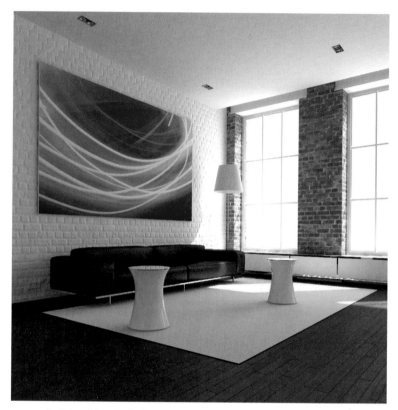

FIG 2.53 Rendering, 600 × 600 Pixels.

Fine-Tuning

We hope that you are already convinced by the result. Now we will refine the effect of the rug and the natural stone wall. The Displacement modifier (VRayDisplacementMod) can add more realism.

Rug, Displacement

The rug does not look like a proper flokati yet. We will fix this. Select the rug and go to the Modify tab in the Command Panel. Select the VRayDisplacementMod modifier from the list. The rug is a plane—a two-dimensional object—so choose 2D mapping (landscape) for Type. Just as with the bump mapping, we need to assign a map to govern the displacement. Under Texmap, choose a Bitmap and assign the file *rug_b.jpg*.

FIG 2.54 Rug, VRayDisplacementMod, Texmap.

It is the same picture as in the *bump map*. Check FILTER TEXMAP and set the AMOUNT to *3.0 cm*. That is sort of the length of our flokati strands. Finally, set RESOLUTION to *256*. That should be enough. The rendering time increases noticeably again, as displacement is always very computationally intensive.

FIG 2.55 Rug, VRayDisplacementMod, Further Parameters.

Brick, Displacement

To bring out the relief structure of the brick wall even more, we will use displacement once more. To that purpose, we have already separated the visible wall surfaces in the AutoCAD file and placed it into the layer *01_wall_brick_displacement*. Generally, you should apply the displacement modifier only to objects visible in the picture, in order to keep calculation time and memory space as low as possible.

Select the layer *01_wall_brick_displacement* and apply the VRayDisplacementMod modifier to the layer. The wall is a three-dimensional object, and we want the displacement to run around the edges of the wall as well. Under Type, choose the option 3D mapping. In the Texmap channel, select the file *brick_b.jpg* for a Bitmap.

FIG 2.56 Layer 01_Wall_Brick_Displacement, VRayDisplacementMod, Texmap.

FIG 2.57 Layer 01_Wall_Brick_Displacement, VRayDisplacementMod, Further Parameters.

FIG 2.58 Layer 01_Wall_Brick_Displacement, VRayDisplacementMod, 3D Mapping.

Activate the option Filter texmap. Set the Amount of the displacement to *2.0 cm.*

In the group 3D mapping/subdivision, set an Edge Length of *3.0 pixels*. You can improve the resolution by changing Resolution to *512*. To make sure that the displacement is continued around the edges, activate the Keep continuity checkbox with an Edge Tresh of *0.01*.

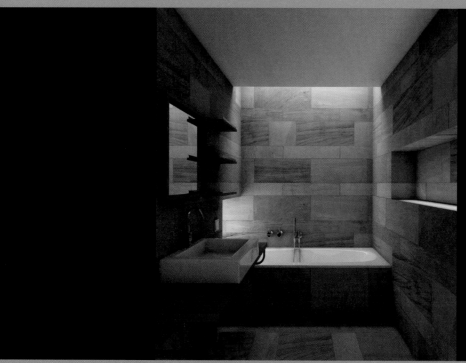

Bathroom

In this chapter, we want to visualize an extraordinary bathroom. The bathtub spans the width of the room and is immersed in light from the ceiling and at the head end. The camera perspective does not give view to the outside of the room, conveying a cave-like atmosphere. This impression is underlined by the use of natural stone on walls and floor.

Preparing the Scene

This time we'll start with a model constructed in 3ds Max. Almost all of the objects used in the scene have rounded edges that can be varied through the TURBOSMOOTH modifier. This increases the realism of the scene, as there are no exact edges in reality, either. Reflections on these gentle curves create contrasts in the scene, which is otherwise lit only diffusely. In this case, we will use a different UVW mapping method. The UVW MAP uses real texture dimensions, which are set in the BITMAP texture.

Open File

Open the file *ch_03_01.max* in the book CD directory *chapters\ch3*. Use the scene for orientation. You can see the openings at the top and to the left of the bathtub. A further opening is located behind the camera; this could be the door.

Architectural Rendering with 3ds Max and V-Ray. DOI: 10.1016/B978-0-240-81477-3.00007-7

FIG 3.1 Bathroom.

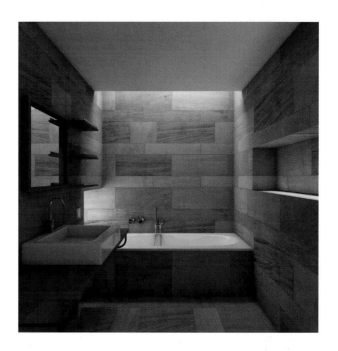

FIG 3.2 Scene, Overview.

If you select individual objects, you can experiment with the TurboSmooth modifier in the Modify tab in the Command Panel. Select the object *wall*. As you can see, the TurboSmooth modifier has Render Iters set to *3*. These are not visible right now. Increase the Iterations value above it. Now the effect is visible in the Viewport, but the scene handling is limited and less readable.

FIG 3.3 TurboSmooth Modifier, 0 Iterations.

FIG 3.4 TurboSmooth Modifier, 2 Iterations.

Camera Setup

To be able to get an impression of the room, you first need to set up a camera. We decided to use a square picture format once more. Set the Resolution in the RENDER SETUP dialog box to *500 × 500* pixels. Create a FREE CAMERA in the TOP VIEWPORT and shift it in y-direction to about *100 cm* in front of the inside of the back wall. In x-direction, center the camera in the room. Now switch to CAMERA VIEWPORT and activate SHOW SAFE FRAMES (press Shift-F) to display the output format. Change the camera lens to *28 mm*. Now shift the camera in the z-direction so that the bottom edge of the washbasin is just about still in the picture. Compare your image with **Figure 3.6**. Render the scene to get a first impression. A test material with a VRAYDIRT map in the DIFFUSE CHANNEL has already been assigned to all objects, and using DEFAULT LIGHTS with Global Illumination on is activated in the V-Ray parameters.

FIG 3.5 Camera Setup, Overview.

FIG 3.6 Camera Setup, Camera Viewport.

Create Light Sources

We are going to create the impression that the bathroom is lit by diffused daylight (or skylight) coming through the openings of the room. We will use V-Ray plane lights to create this effect; that is, rectangular planes emitting diffuse light in one direction. They are in front of the openings and are always slightly larger than these in order to create even illumination. The *ceiling light* is to be the strongest light source. The *side light* is also very intense. The *back light* behind the camera adds a bit of extra light to the room, but is not directly noticeable. First, create a new *light* layer in the LAYER MANAGER.

- Ceiling light

Create a new VRAYLIGHT in the TOP VIEWPORT (COMMAND PANEL/CREATE/LIGHTS/V-RAY). Name it *ceiling light*. Switch to the MODIFY tab in the COMMAND PANEL. Set TYPE to PLANE. Position the light in the center of the opening in the ceiling. Adapt the dimensions with the parameters HALF-LENGTH and HALF-WIDTH. They designate half the distance from the center. Settings of *110 cm* and *25 cm* are recommended; in any case, the light should overlap the opening by a

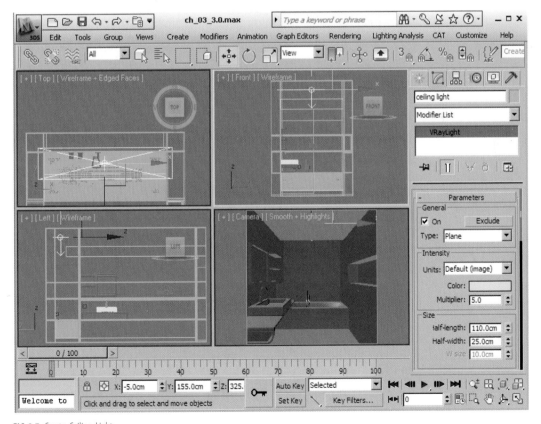

FIG 3.7 Create Ceiling Light.

few centimeters. Shift the *ceiling light* in the CAMERA VIEWPORT upwards in the z-direction until it is obscured by the ceiling, or change the z-coordinate to *325 cm*.

- Side light

Change to the LEFT VIEWPORT. Create a VRAYLIGHT *side light* with the dimensions *45 cm × 45 cm*. Center it in front of the opening above the bathtub. Go back to the TOP VIEWPORT and move it in the x-direction to about 5 cm from of the outside of the left wall.

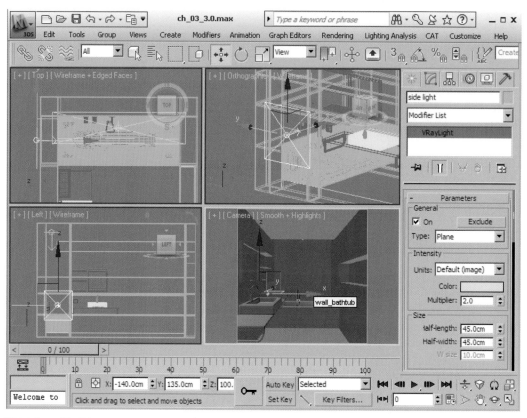

FIG 3.8 Create Side Light.

- Back light

In the FRONT VIEWPORT, create a VRAYLIGHT *back light*. Enter *60 cm* for HALF-LENGTH and *120 cm* for HALF-WIDTH and shift the light to the center of the opening. In the TOP VIEWPORT, move it in the y-direction to about 10 cm beneath the external wall.

Before rendering the scene, you still need to input the parameters for light intensity and color. *Ceiling light* and *side light* should simulate daylight.

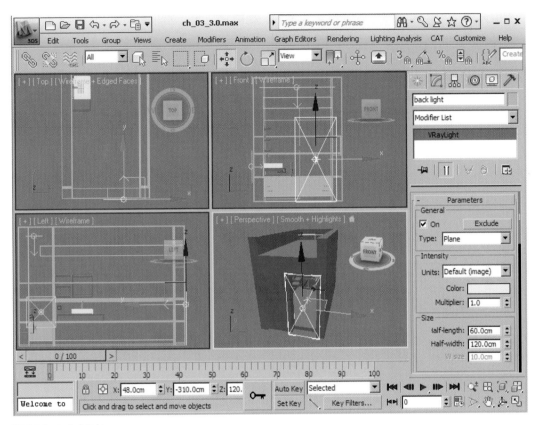

FIG 3.9 Create Back Light.

So assign a light-blue color (to emulate the skylight color)—for example, RGB values *150, 200, 225*. Set the value for light intensity: the MULTIPLIER for the *ceiling light* to *5.0* and the *side light* to *2.0*. A test material VRAYMTL with a VRAYDIRT map has already been assigned to all objects. You can view it in the MATERIAL EDITOR.

FIG 3.10 Color Selector, Ceiling Light and Side Light.

The *back light* should be slightly warmer; use a color with the RGB values *250, 220, 170*. Leave the MULTIPLIER at *1.0*.

FIG 3.11 Color Selector, Back Light.

FIG 3.11 Color Selector, Back Light.

You will need to fine-tune these settings after texturing the scene; for the next few steps, setting suggestions are just basic guidelines to start with. You should also enter the following settings in the RENDER SETUP dialog box.

• V-Ray:: Frame buffer

Activate the V-Ray output window by checking the ENABLE BUILT FRAME BUFFER checkbox.

FIG 3.12 Render Setup, V-Ray:: Frame Buffer.

• V-Ray:: Global switches

Deactivate the HIDDEN LIGHTS checkbox and make sure that DEFAULT LIGHTS is set to the option OFF WITH GI.

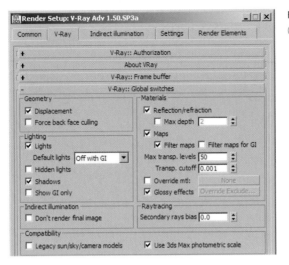

FIG 3.13 Render Setup, V-Ray::
Global Switches.

- V-Ray:: Image sampler (antialiasing)

Set the Image Sampler to Adaptive Subdivision and Antialiasing filter to Area.

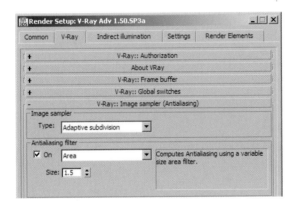

FIG 3.14 Render Setup, V-Ray::
Image Sampler (Antialiasing).

- V-Ray:: Adaptive subdivision image sampler

Set the Min. rate to −1 and Max. rate to 2.

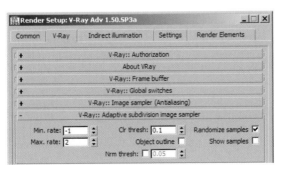

FIG 3.15 Render Setup, V-Ray::
Adaptive Subdivision Image Sampler.

- V-Ray:: Color mapping

In this rollout, set the GAMMA value to *1.0*. Carry out the Gamma correction in the *Frame Buffer* with the DISPLAY COLORS IN SRGB SPACE button.

FIG 3.16 Render Setup, V-Ray:: Color Mapping.

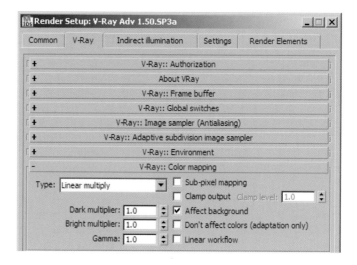

- V-Ray:: Indirect Illumination (GI)

Check the ON checkbox. Set PRIMARY BOUNCES to IRRADIANCE MAP and SECONDARY BOUNCES to LIGHT CACHE.

- V-Ray:: Irradiance map

Set the CURRENT PRESET to LOW and activate the SHOW CALC. PHASE checkbox.

FIG 3.17 Render Setup, V-Ray:: Irradiance Map.

- V-Ray:: Light cache

Set SUBDIVS to *500*. SCALE should be set to SCREEN. Once again, activate the SHOW CALC. PHASE checkbox.

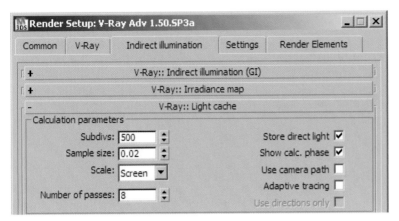

FIG 3.18 Render Setup, V-Ray::
Light Cache.

Activate the CAMERA VIEWPORT and render the scene. The result should look
similar to **Figure 3.19**.

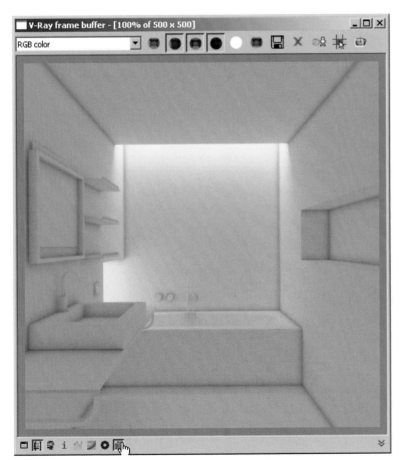

FIG 3.19 V-Ray Frame Buffer.

Warning
Make sure to activate
Gamma correction with
the DISPLAY COLORS IN sRGB
SPACE button.

Texture the Scene

Now we are going to create the materials for the scene, step by step. We want to create contrast with the soft natural stone on walls and floor by adding highlights to the interior design objects. The natural stone on the floor is distinguished by a different scale from the stone used for walls and the side of the bathtub.

Natural Stone, Floor

The floor is the first object where we will use the natural stone.

- Create a new VRayMtl in the Material Editor and name it *natural_stone_floor*.
- Diffuse channel

Place a *VRayDirt* map in the Diffuse channel. Change the parameters for Radius to *10 cm*, Falloff to *1.0*, and Subdivs to *32*.

FIG 3.20 Natural_Stone_Floor, VRayDirt, Parameters.

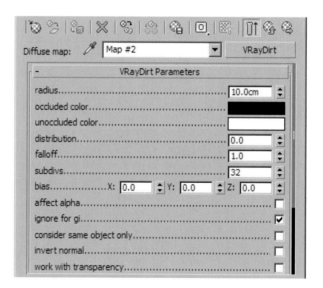

This achieves a soft gradient of Ambient Occlusion. In the Unoccluded Color channel, select a Bitmap. Open the image *stone_d.jpg* from the *textures* subdirectory. Make sure that the Select Bitmap Image File dialog box is set to Use system default gamma, to satisfy the linear workflow (LWF). In the Bitmap settings, activate the Use Real-World Size checkbox and enter the dimensions of the map. Set Width to *250 cm* and Height to *80 cm*. Then go to the Bitmap Parameters group and set Filtering to Summed Area. This setting adds more sharpness to the texture. Using this parameter is generally a good idea.

FIG 3.21 Natural_Stone_Floor, VRayDirt, Bitmap.

> 📖 **Tip:** Also activate the SHOW STANDARD MAPS IN VIEWPORT option in the MATERIAL EDITOR to make sure that the texture is displayed on the objects in the VIEWPORT.

- BUMP CHANNEL

Place a BITMAP in the BUMP CHANNEL as well. Select the image *stone_b.jpg*. Proceed in the same manner as in the DIFFUSE CHANNEL. Assign the same values. Leave FILTERING set to PYRAMIDAL. In the BUMP CHANNEL, a higher sharpness is a disadvantage; it causes textures to look somewhat rough. Reduce the value for the amount of bump mapping to *5*. That will be enough to show the stone texture.

FIG 3.22 Natural_Stone_Floor, Bump Map.

- UVW map

In the Layer Manager, select the layer *00_floor*. In the Modify tab of the Command Panel, assign the UVW map modifier to the selection. Make sure that the modifier is set to Box for Mapping and that the Real-World Map Size checkbox is checked.

FIG 3.23 Layer 00_Floor, UVW Mapping.

- Assign material

Open the Layer Manager. Select the layer *00_floor* and assign the material.

Natural Stone, Wall

The walls are made from the same material as the floor. We will assign different dimensions to the bitmap.

- Create a copy of the material *natural_stone_floor* and rename it *natural_stone_wall*.
- Diffuse channel

In the VRayDirt map, set the Radius to *50 cm* to enlarge the area of the contact shadow. Now go into the Bitmap. The natural stone wall will have stones of different sizes than the floor. Change the Width to *400 cm* and the Height to *57 cm*. To ensure that the joint structure fits the geometry, we need to modify the parameters for Offset. Enter an Offset Width of *11 cm* and Offset Height of *–8.3 cm*. We used trial and error to find the best settings.

FIG 3.24 Natural_Stone_Wall, VRayDirt, Bitmap.

- Bump channel

Adapt the Bitmap settings as you did in the Diffuse channel.

- UVW Map

Open the Layer Manager and expand the layer *00_wall*. In the layer, select only the two objects *wall* and *wall_back*. Assign the UVW Map modifier to these objects. Again, set Mapping to Box and check the Real-World Mapping checkbox.

- Select the entire layer *00_wall* and assign the material.
- UVW Map for object *wall_bathtub*

Select the object *wall_bathtub* within the layer *00_wall*. Assign the UVW Map modifier, just as with the other two objects. The bathtub panel will be formed by several large slabs. Uncheck the Real-World Mapping checkbox and enter the parameters for Length, Width, and Height of the UVW Map manually. Enter *0.8 cm* for Length and Width and *2 cm* for Height. Then shift the UVW Map in the z-direction until no horizontal joint is visible. Expand the UVW Mapping modifier in the list panel and activate the gizmo by clicking on it. It is now highlighted in yellow and you can drag it as usual.

FIG 3.25 Object Wall_Bathtub, UVW Mapping.

FIG 3.26 Camera Viewport, Shift Gizmo.

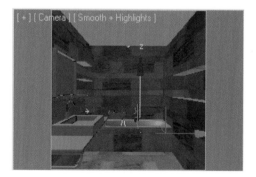

Ceramic

The bathtub and washbasin have a smooth, white ceramic surface, characterized by a high degree of reflection and highlights on the edges.

- Create a new VRayMtl ceramic.
- DIFFUSE CHANNEL

Place a VRayDirt map in the DIFFUSE CHANNEL. Assign a gray value of *230* to UNOCCLUDED COLOR—in other words, pure white. Set RADIUS to *20 cm*, FALLOFF to *1.0* and SUBDIVS to *32*.

FIG 3.27 Ceramic, VRayDirt Parameters.

- REFLECTION CHANNEL

Set the reflection color to *white* and check FRESNEL REFLECTIONS. Remove the link between HIGHLIGHT GLOSSINESS and REFLECTION GLOSSINESS by clicking on the L button next to it. Add a soft highlight to the hard reflection by reducing the HIGHLIGHT GLOSSINESS to *0.75*.

FIG 3.28 Ceramic, Reflection.

- Assign the material to the layers *00_bathtub* and *00_washbasin*.

FIG 3.29 Ceramic, Material Editor View.

Chrome

There are also lots of shiny chrome materials in our scene. The faucet, the three shelf edges, and the washbasin brackets are chromed.

- Create a new VRayMtl and name it *Chrome*.
- Diffuse channel

Change the color to black.

- Reflection channel

Select a Falloff map. This makes the reflection dependent on the viewing direction. Toward the edge of the sphere, the reflection becomes increasingly stronger. To make sure that the chrome still reflects if viewed from the front, you need to reduce the black area. Assign an RGB setting of *125, 125, 125* to the black color swatch under the Front:Side parameter. Back in the main material, deactivate the link between Highlight Glossiness and Reflection Glossiness by clicking on the L, then set Highlight Glossiness to *0.9*. This places a softer highlight on the edges of the sharp chrome reflection, emphasizing the object shape.

FIG 3.30 Chrome, Reflection.

FIG 3.31 Chrome, Falloff Parameters.

- In the LAYER MANAGER, select the layers *00_chrome* and *00_faucet* and assign the material.

FIG 3.32 Chrome, Material Editor View.

Plaster

The ceiling is covered in very light, almost white plaster. The plaster texture is created via a *bump map*.

- Create a new VRAYMTL *plaster*.
- DIFFUSE CHANNEL

A VRAYDIRT map is sufficient in the DIFFUSE channel. For UNOCCLUDED COLOR, assign a gray value of *220*. The other settings are the same as before: *10 cm* for RADIUS, *1.0* for FALLOFF and *32* SUBDIVS.

FIG 3.33 Plaster, VRayDirt Parameters.

- Bump channel

Place the image *plaster_b.jpg* from the *textures* subdirectory into the BUMP CHANNEL as the bitmap. Enter *50 cm* each for WIDTH and HEIGHT. Make sure that the USE REAL-WORLD SCALE checkbox is activated. To be able to see the texture in the CAMERA VIEWPORT, turn on SHOW STANDARD MAPS IN VIEWPORT in the MATERIAL EDITOR.

FIG 3.34 Plaster, Bump Map,
Bitmap Parameters.

- Assign the material to the layer *00_ceiling.*

Wood

The shelf under the washbasin and the shelves on the wall have wooden surfaces. We will use a very soft reflection to represent a moderately shiny surface.

- In a free slot of the MATERIAL EDITOR, create a new VRAYMTL and name it *wood.*
- DIFFUSE CHANNEL

Place a VRAYDIRT map into the DIFFUSE CHANNEL. Choose a RADIUS of *50 cm*, and set FALLOFF to *1.0* and SUBDIVS again to *32*. Place a BITMAP in the UNOCCLUDED COLOR channel. Select the image *wood_d.jpg* from the *textures* subdirectory. Set WIDTH and HEIGHT to *20 cm*.

FIG 3.35 Wood, VRayDirt
Parameters.

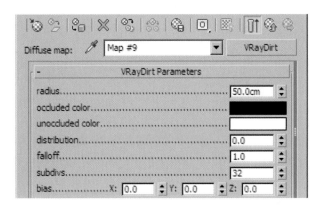

FIG 3.36 Wood, VRayDirt, Bitmap
Parameters.

> 📖 **Tip:** In the Material Editor, activate the option Show Standard Maps in
> Viewport.

• Reflection channel

Set the Reflect swatch to a gray of *40*. Reduce the value for Reflection
Glossiness to *0.75*. This very soft reflection makes it necessary to increase the
sample subdivisions, so set Subdivs to *32*. Now activate the Fresnel Reflections
checkbox.

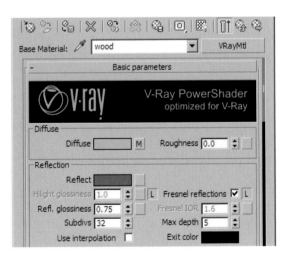

FIG 3.37 Wood, Reflection.

• Shellac material

While still in the wood material, click on the VRayMtl button next to the
material name. Choose a Shellac material. In the resulting dialog box, select
Keep Old Material as Sub-Material. In the Shellac material, increase Shellac
Color Blend to *100*.

103

FIG 3.38 Wood, Shellac Material, Overview.

Now click on the SHELLAC MATERIAL slot. Within this standard material, we need the BLINN BASIC PARAMETERS rollout. Change the DIFFUSE COLOR to *black* to achieve a highlight overlay. Create the highlight by setting the SPECULAR LEVEL (that is, the reflection intensity) in the SPECULAR HIGHLIGHTS group to *45*. Change the GLOSSINESS to *35* to make the reflection softer. You can leave the SOFTEN value at *0.1*. Now your wood has a soft white highlight.

FIG 3.39 Wood, Shellac Material, Standard Material Parameters.

• UVW map

In the LAYER MANAGER, select the layer *00_wood*. Apply the UVW MAP modifier to it. Use BOX for MAPPING and activate the USE REAL-WORLD MAP SIZE checkbox.

• Assign material

In the LAYER MANAGER, select the layer *00_wood* and assign the material. In the CAMERA VIEWPORT, notice that the wood grain runs across, not lengthwise. Activate the UVW MAPPING modifier gizmo, just as you did with the object *wall_bathtub*. Rotate it by *90 degrees*. Now the texture is aligned lengthwise, as we wanted.

FIG 3.40 Layer 00_Wood, UVW Mapping, Rotate Gizmo.

FIG 3.41 Wood, Material Editor View.

Mirror Glass

The material for the mirror is really simple. It is black and completely reflecting.

- Create a new VRayMtl *mirrorglass*.
- Diffuse channel

Change the color to *black*.

- Reflection channel

Here, change the color to *white*; the material is 100 percent reflective.

FIG 3.42 Mirrorglass, Overview.

- Select the layer *00_mirror* and assign the material.

Lacquer, Switch

Only the little switch to the right of the mirror will have this material. But the challenge lies in overcoming the impression that the switch is floating. A little trick can help us here.

- Create a new VRayOverrideMtl and name it *lacquer_switch*.

In the VRayOverrideMtl, drag the material *ceramic* to the Base Material channel. To achieve a stronger shading around the switch, overwrite the natural color bleeding during the calculation of indirect light with the GI material. For a light material, the color bleeding would also be very light. To achieve a darker effect, create a new VRayMtl in the GI channel and change only the Diffuse color to *black*. Now the material reflects dark photons.

FIG 3.43 Lacquer_Switch, VRayOverrideMtl, Overview.

FIG 3.44 Lacquer_Switch, VRayOverrideMtl, GI Material Parameters.

- Assign the material to the layer *00_switch*.

Rubber

The rubber material will be needed only when we create the next material. For the sake of completeness, we are listing it separately nonetheless.

- Create a new VRAYMTL *rubber*.
- DIFFUSE CHANNEL

Change only the color of the DIFFUSE CHANNEL, to a gray with a setting of *30*.

- Shellac material

We use the SHELLAC material again to help us achieve a soft shine. Click on the VRAYMTL channel next to the material name. Choose a SHELLAC material and KEEP OLD MATERIAL AS SUB-MATERIAL. Change the SHELLAC COLOR BLEND to *100*. Go to the SHELLAC material channel. Set *black* as diffuse color. In the SPECULAR HIGHLIGHTS group, increase the value for SPECULAR LEVEL to *65* and GLOSSINESS to *30*.

FIG 3.45 Rubber, Shellac Material, Overview.

FIG 3.46 Rubber, Shellac Material, Standard Material Parameters.

FIG 3.47 Rubber, Material Editor View.

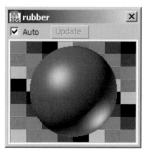

Multimaterial, Showerhead

For texturing the showerhead, we will use a multimaterial. That way we can assign different materials to an object by using multiple material IDs.

- First we need a new material. Create a new MULTI/SUB-OBJECT material and name it *multi-material_showerhead*.
- Multi/Sub-Object

Reduce the channels by clicking on the SET NUMBER button. Enter *2* for the number. Drag the *chrome* material to the first channel and the previously created *rubber* material to the second channel. Enter the names accordingly.

FIG 3.48 Multimaterial_Showerhead, Multi/Sub-Object Material, Overview.

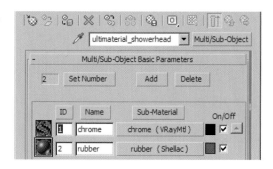

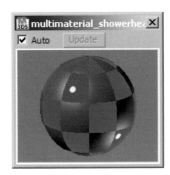

FIG 3.49 Multimaterial_Showerhead, Material Editor View.

- Assign material

Assign the material to the objects *shower_head* and *shower_faucet*. The *rubber* material is assigned to the handles, the *chrome* material to the rest.

FIG 3.50 Multimaterial_Showerhead, Selecting Objects.

- Determine ID

Select the objects *shower_head* and *shower_faucet* in the scene. Isolate the selection. Select the object *shower_head*. In the MODIFY tab of the COMMAND PANEL, activate the selection option POLYGON for EDITABLE POLY. Select all objects. In the POLYGON: MATERIAL-IDs rollout, enter the material ID *1* in the SET ID box.

Use the rectangular selection tool to select only the polygons of the top cylinder. Set the material ID for this selection to *2*. Repeat this process with the object *shower_faucet*. Again, enter the material ID *2* for only the polygons of the top cylinder.

109

FIG 3.51 Shower_Head, Assign Material ID 1 to all Polygons.

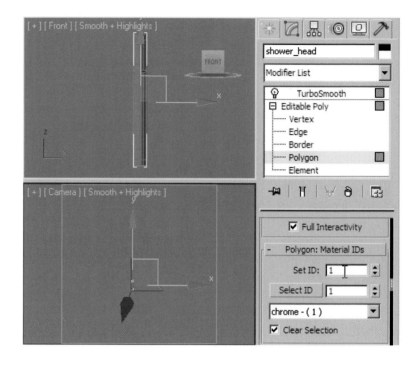

FIG 3.52 Shower_Faucet, Assign Material ID 2 to Selected Polygons.

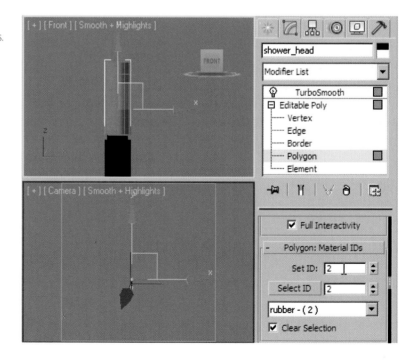

Frosted Glass

The last material in our scene is a shimmering green frosted glass. We will assign it to the hardly noticeable space within the wall recess. While fine-tuning, we will place a plane light beneath the frosted glass to accentuate the picture.

- Create a new VRayMtl *frosted glass*.
- Diffuse channel

Change the RGB value to *195, 200, 195* (a light green).

- Reflection channel

For the reflection intensity, set a gray of *185*. To achieve an unsharp reflection, reduce Refl. Glossiness to *0.9* and increase Subdivs to *20*. Check the Fresnel Reflections checkbox.

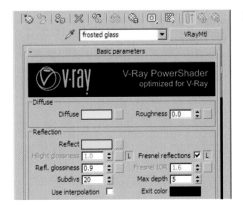

FIG 3.53 Frosted Glass, Reflection.

- Refraction channel

Change the Refract gray value to *180*. Reduce Glossiness to *0.4* and set Subdivs to *20*. Set the Fog color to RGB *170, 195, 180* to add color to the frosted glass. Reduce Fog multiplier to *0.01*. Check the Affect shadows checkbox.

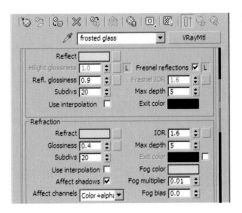

FIG 3.54 Frosted Glass, Refraction.

- Assign the material to the layer *00_frostedglass*.

FIG 3.55 Frosted Glass, Material Editor View.

All objects are now textured. If you have enough time, try rendering the scene at a higher resolution with better render settings. In the Irradiance Map, leave the Preset at Low. With a higher resolution, adapt the Light Cache value for Subdivs. You should enter a setting that corresponds to your resolution, for example, *1500* for a resolution of *1500 × 1500* pixels. You can achieve finer details by increasing the Min. rate and Max. rate values in the Adaptive subdivision image sampler. The values should always be three to four numbers apart to avoid unnecessary subdividing of image areas that do not require fine subdivision during sampling, which would increase the rendering time without increasing quality. Try entering the values *1* and *5*.

Fine-Tuning

You will notice that the scene is still rather dark. We need to increase the intensity of the plane lights. To add an extra accent, we'll place another light under the frosted glass, angled upwards. This will illuminate the recess in the wall.

- *ceiling light* and *side light*

Increase the light intensity by increasing the Multiplier for the *ceiling light* to *10* and the *side light* to *5*.

- light_recess

In the Top Viewport, create a new VRayLight. Name it *light_recess*. Set Type to Plane. For Size, enter *7.0 cm* for Half-length and *175 cm* for Half-width. Set the light Color to RGB *150, 200, 170*. The light intensity is again determined by the Multiplier setting; choose *3.0*. Position the light in the x-/y-direction so that it is centered in relation to the object *frostedglass_recess*. Move it in the z-direction so that it is underneath that object.

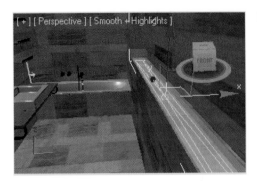

FIG 3.56 Light_Recess, Positioning.

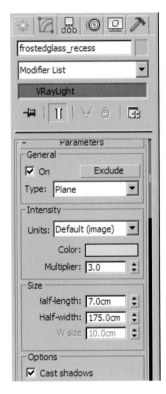

FIG 3.57 Light_Recess, Parameters.

Final Render Settings

V-Ray

Open the RENDER SETUP dialog box and go to the V-RAY tab. The following bullet points each relate to the relevant rollout.

- V-Ray:: Image sampler (antialiasing)

Set TYPE to ADAPTIVE DMC and choose BLACKMAN as ANTIALIASING FILTER.

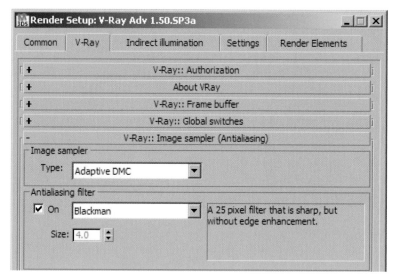

FIG 3.58 Render Setup, V-Ray:: Image Sampler (Antialiasing).

- V-Ray:: Adaptive DMC image sampler

Set MIN. SUBDIVS to *4* and MAX. SUBDIVS to *10*.

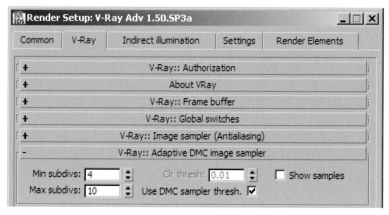

FIG 3.59 Render Setup, V-Ray:: Adaptive DMC Image Sampler.

- V-Ray:: Color mapping

Activate the option CLAMP OUTPUT. Image areas that are too dark or too light and cannot be represented are clamped—or cut off, so to speak—at the values that can just about still be represented. A calculated gray with a lightness of over 255 will therefore be represented as white, with a lightness of 255.

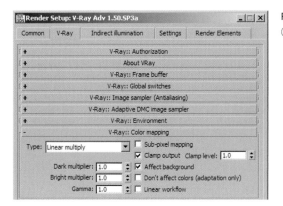

FIG 3.60 Render Setup, V-Ray::
Color Mapping.

Indirect Illumination

Go to the INDIRECT ILLUMINATION tab.

- V-Ray:: Indirect Illumination (GI)

For PRIMARY BOUNCES, choose IRRADIANCE MAP, and for SECONDARY BOUNCES choose
LIGHT CACHE as before.

- V-Ray:: Irradiance map

Set CURRENT PRESET to MEDIUM. For BASIC PARAMETERS, increase the HSPH. SUBDIVS to
60 and INTERP. SAMPLES to 30.

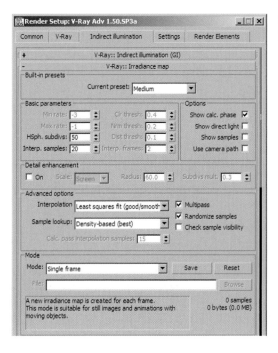

FIG 3.61 Render Setup, V-Ray::
Irradiance Map.

- • V-Ray:: Light cache

Change the SUBDIVS value to *2500* and the SAMPLE SIZE to *0.01*. Activate the option USE LIGHT CACHE FOR GLOSSY RAYS.

FIG 3.62 Render Setup, V-Ray:: Light Cache.

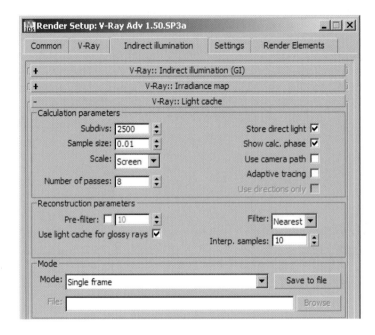

Now render the picture with a resolution of *2500 × 2500* pixels. Your computer will be busy for a while, so you can lean back, relax, and proudly contemplate the completion of your second workshop.

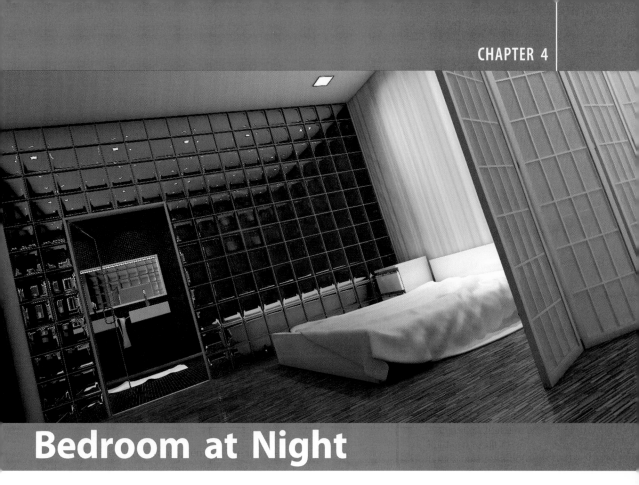

Bedroom at Night

In this chapter, we are going to create a bedroom—perhaps in a luxury penthouse above the city rooftops. The foreground of the picture will be dominated by the bedroom itself, with a Japanese screen and a generously sized bed. The bedroom has dark wood parquet flooring. A wall of glass blocks separates the bedroom from the bathroom. With its minimalist interior and stylish small tiles, it completes the elegant overall atmosphere. The window spans the whole length of the room and offers a great view of the city skyline.

Preparing the Scene

For this scene, we are again working with a combination of the AutoCAD model and loading furniture constructed in 3ds Max. The absolute highlight of the scene is undoubtedly the wall of glass blocks that separates the bedroom and the bathroom. The complicated geometry and the material glass mean a longer render time. This time we will use IES profiles for our light sources.

Architectural Rendering with 3ds Max and V-Ray. DOI: 10.1016/B978-0-240-81477-3.00008-9

FIG 4.1 Bedroom.

Open File

Open the file *ch_04_01.max* from the book CD (*chapters\ch_04*). The file has no contents yet, as we've entered only basic settings for the V-Ray render settings.

Link AutoCAD Files

Link the AutoCAD file via the 3DS/REFERENCES/FILE LINK MANAGER. In the dialog box, go to the ATTACH tab and select the file *ch_04_01.dwg* from the *dwg* subdirectory. For PRESET, choose the ACAD profile created in Chapter 2. The AutoCAD file is linked and new layers are created corresponding to the AutoCAD layers. Have a closer look at these.

FIG 4.2 File Link Manager.

FIG 4.3 Scene after Linking.

Load Furniture

Load the furniture via 3DS/IMPORT/MERGE. Select the file *ch_04_mg.max* from the *merge* subdirectory. In the MERGE FILE dialog box, select all objects and confirm the selection. The scene is now filled with furniture. Let's have a closer look at these items as well.

FIG 4.4 Merge Dialog Box, ch_04_mg.max.

FIG 4.5 Perspective Viewport, Scene after Importing Furniture.

Assign Test Material

The imported objects have already been assigned the *test material* that you have already encountered in previous chapters. Use the eyedropper to drag this material to an empty slot in the MATERIAL EDITOR. Select all layers in the LAYER MANAGER and assign the *test material*. Assign the attribute *invisible* to the layers *01_window_glass* and *01_wall_glassblocks_glass*, also in the LAYER MANAGER.

FIG 4.6 Layer Manager, Hide Glass Layers.

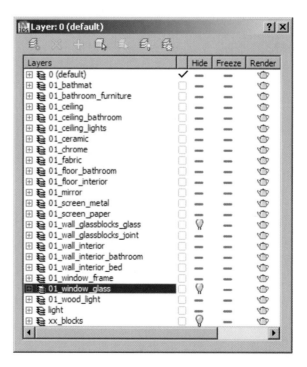

Open the RENDER SETUP dialog box. In the V-RAY tab, go to the V-RAY:: ENVIRONMENT rollout. Activate the checkbox for GI ENVIRONMENT (SKYLIGHT) OVERRIDE and choose a blue color in the swatch, such as RGB *0, 5, 10*. Make sure that the V-RAY:: GLOBAL SWITCHES rollout has its DEFAULT LIGHTS set to OFF WITH GI.

FIG 4.7 Render Setup, V-Ray::
Environment.

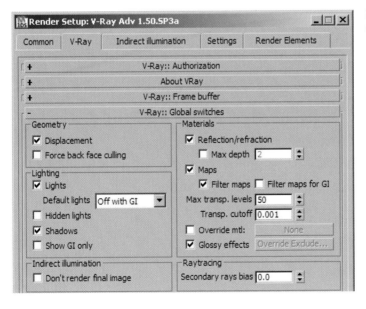

FIG 4.8 Render Setup, V-Ray::
Global Switches.

Camera Setup

Create a new camera (TARGET CAMERA) in the TOP VIEWPORT. Move the camera to the bottom-left corner of the bedroom and the target just below the separating wall, to about the center of the bathtub. For an effective perspective, set the camera to a height of about *60 cm* and the target to about *110 cm*. Set a small lens of about *20 mm*, so that you can display the room in its entirety.

FIG 4.9 Camera Setup, Positioning.

We decided to roll the camera slightly to make this scene a little more dynamic. Select the camera and open the dialog box MOVE TRANSFORM TYPE-IN by pressing F12. Enter *–16* for ROLL. In the RENDER SETUP dialog box, choose an attractive aspect ratio of *2:1* with a resolution of *1000 × 500* pixels. Compare your camera position with **Figure 4.9**. Render the scene in the CAMERA VIEWPORT to get a first impression. At the moment, the scene is still submerged in very dark blue.

FIG 4.10 Move Transform Type-In Dialog Box, Roll Camera.

Basic Illumination of Scene

Before assigning materials to the scene, we will set up the desired light sources. That way we can assess and test the light distribution at a low render time. We will use a VRAYIES light, a light source with a photometric profile. Practically all major lighting manufacturers now offer such IES

profiles. They contain data about the light intensity, emission characteristics, and color temperature of light.

Ceiling Lights, Bathroom

In the TOP VIEWPORT, create a new VRayIES light (COMMAND PANEL/CREATE/LIGHTS/ V-RAY/VRayIES). Position it in one of the ceiling lights in the bathroom. Note that the light is directional—it has a target. The target should be situated directly underneath the light. In the LEFT VIEWPORT, move the light to under the ceiling light and the target to the floor. Name the light source *light_bathroom* and go to the light characteristics (COMMAND PANEL/MODIFY).

FIG 4.11 Setting Up Ceiling Lights in Bathroom, Overview.

Click on the NONE button and select the file *bathroom.ies* from the *ies* subdirectory.

FIG 4.12 Open Dialog Box, Open IES File.

123

The parameter SHADOW BIAS lets you specify how far the shadow is removed from an object. Enter a setting of *0.01 cm*, which is very low. Improve the shadow calculation interpolation by increasing the SHAPE SUBDIVS setting to *32*. Then change the COLOR MODE to TEMPERATURE. The COLOR TEMPERATURE should be set to *6500.00* (Kelvin), which corresponds to a cool white. Leave the light intensity, determined by the POWER parameter, at *1575.00*.

Ceiling Lights, Bedroom

For the bedroom, create VRAYIES light sources underneath the ceiling lights. Name them *light_bedroom*. Proceed in the same way as for the bathroom, but this time move the target of the light to the right in the TOP VIEWPORT, to about the level of the bed's headboard. Use the file *bedroom.ies*. For COLOR MODE, set TEMPERATURE again. Change the COLOR TEMPERATURE to a warmer tone: *4500.00*. The POWER should be set to *6600*. That should be sufficient as light setup for now; we may have to fine-tune the settings after assigning the materials.

Now you can render the scene with the preset V-Ray settings. For the light calculation, we set IRRADIANCE MAP and LIGHT CACHE to low values.

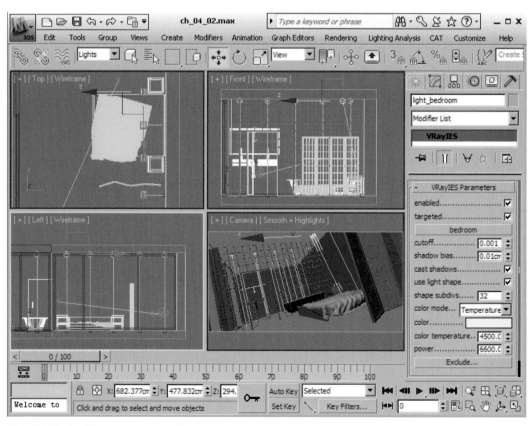

FIG 4.13 Setting Up Ceiling Lights in Bedroom, Overview.

Texture the Scene

Now it's time to create the materials for the scene again and then assign them to the objects. For this scene, this process will be more involved, as there are more textures being used than in the previous scenes.

Plaster, White

This is the standard material for ceiling and wall surfaces, which are meant to be less noticeable. We will use a VRayDirt map and a discreet plaster texture in the Bump channel.

- Create a new VRayMtl *plaster_white*.
- Diffuse channel

Place a VRayDirt map with a large radius of *50 cm* into the Diffuse channel. Set Falloff to *1.5*. Increase subdivs to *32* to improve resolution of shadows. Choose a gray of *205* for unoccluded color and *5* for occluded color.

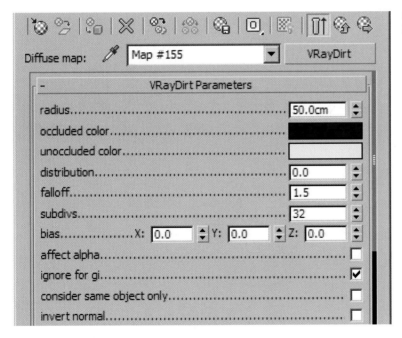

FIG 4.14 Plaster_White, VRayDirt Parameters.

- Bump channel

Place a Bitmap into the Bump channel. Select the picture *plaster_b.jpg* from the *textures* subdirectory. Switch Use Real-World Scale on and enter *50 cm* for Height and Width of the Bitmap. Reduce the Bump Map Intensity to *15*, which is enough to represent a hint of plaster texture.

FIG 4.15 Bump Channel, Bitmap Parameters.

• UVW map

In the LAYER MANAGER, select the following layers and assign the UVW MAP modifier:

• 01_ceiling
• 01_ceiling_bathroom
• 01_wall_glassblocks_joint
• 01_wall_interior

Set the mapping to BOX and activate the REAL-WORLD MAP SIZE checkbox.

FIG 4.16 UVW Mapping Parameters.

• Assign the material to the layers listed previously.

Parquet, Bedroom

The bedroom floor is made from dark wood parquet flooring in small sections. The material reflects, depending on the wood texture.

• Create a VRayMtl called *parquet_bedroom* in a new slot of the Material Editor.
• Diffuse channel

In the Diffuse channel, create a VRayDirt map with a radius of *50 cm*, falloff set to *1.5*, and subdivs set to *16*. In the unoccluded color channel, select the image *floor_parquet_d.jpg* as the Bitmap. Set Width to *450 cm* and Height to *200 cm*.

FIG 4.17 Parquet_Bedroom, VRayDirt Parameters.

FIG 4.18 Parquet_Bedroom, VRayDirt, Bitmap Parameters.

📖 **Tip:** Activate the Show Standard Maps in Viewport option so that you can assess the assigned material in the Viewport later.

- REFLECTION CHANNEL

Right-click on the UNOCCLUDED COLOR channel and use the command COPY to copy the BITMAP to the clipboard. By right-clicking on the REFLECTION CHANNEL and using the command PASTE (COPY), you insert a copy of the map. Any changes made here do not affect the original map. Replace the picture of the Reflection BITMAP with the image *floor_parquet_s.jpg*. You do not need to change the dimensions, because the image area has exactly the same size. Reduce the BLUR to *0.1* to sharpen the image. The reflective sections of the material are then separated more precisely from the areas that reflect little or not at all.

FIG 4.19 Parquet_Bedroom, Reflection Channel, Bitmap Parameters.

As the reflection is still rather strong, you can darken the light areas of the picture in order to reduce the reflection. Go to the OUTPUT rollout of the BITMAP. Activate the ENABLE COLOR MAP checkbox. In the curve editor, drag the white point on the right down to *0.15*.

FIG 4.20 Color Map, Adapted Curve.

- BUMP CHANNEL

Insert a copy of the BITMAP from the VRAYDIRT map in the BUMP CHANNEL as well. Replace the image here with the file *floor_parquet_b.jpg*. We want the parquet to have a very slight, soft relief, so increase BLUR to *1.5*. Reduce the bump map intensity to *10*.

FIG 4.21 Bump Channel, Bitmap Parameters.

- UVW map, assign material

Select the layer *01_floor_interior* and assign the UVW MAP modifier and then the material.

FIG 4.22 Parquet_Bedroom, Material Editor View.

Color Stripes

We want the wall behind the bed to look cheerful and refreshing, so we will cover it with a colorful striped wallpaper.

- Create a new VRAYMTL called *colorstripes*.
- DIFFUSE CHANNEL

In the DIFFUSE CHANNEL, create a VRayDirt map again. Use the same parameters as for the previously created materials. Select the image *colorstripes_d.jpg* in the *textures* subdirectory for the BITMAP, which you can assign to the UNOCCLUDED COLOR channel. In the BITMAP, activate USE REAL-WORLD SCALE with the dimensions *500 cm* for WIDTH and *250 cm* for HEIGHT. Make the map visible in the VIEWPORT by activating the option SHOW STANDARD MAPS IN VIEWPORT.

FIG 4.23 Colorstripes, VRayDirt Parameters.

FIG 4.24 Colorstripes, VRayDirt, Bitmap Parameters.

• UVW map, assign material

In the LAYER MANAGER, select the layer *01_wall_interior_bed* and again assign the UVW MAP modifier. The MAPPING group should have BOX selected and the REAL-WORLD MAP SIZE checkbox should be activated. Now assign the material to the layers.

FIG 4.25 Colorstripes, Material Editor View.

Tiles, Small

We chose elegant, small format tiles for the bathroom walls and floor. The dark shade of brown varies slightly, creating an interesting but unobtrusive pattern. We use a TILES map that allows us to create joint structures of any size.

* Name the new VRAYMTL *tiles_small*.
* DIFFUSE CHANNEL

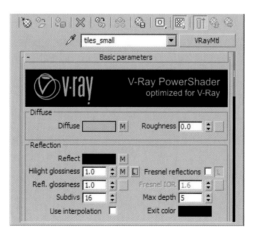

FIG 4.26 Tiles_Small, Overview.

Create a TILES map in the DIFFUSE CHANNEL. We are working with real-world sizes again to assess the texture more accurately, so activate USE REAL-WORLD SCALE. Set the texture WIDTH and HEIGHT to *100 cm*. When we create the joint structure, the parameters always relate to this dimension of one square meter. Reduce the BLUR to *0.1*. This makes the texture sharper and is especially important with small joints, so that you can still see them. Set the STANDARD CONTROLS rollout to STACK BOND; the tiles are simply stacked in rows without offset.

FIG 4.27 Diffuse Channel, Tiles, Coordinates.

Go to the ADVANCED CONTROLS rollout and to the TILES SETUP group. Here you determine what the tiles will look like. Set the TEXTURE swatch to a dark shade of brown with RGB *3, 2, 1*. HORIZ. COUNT and VERT. COUNT specify how many tiles are in the viewed section. Enter a setting of *30*. At our texture dimension of one square meter, this means a tile edge length of about *3.3* cm. Increase the COLOR VARIANCE to achieve color variation. For our example, enter *0.2*. Adapt the joints with the GROUT SETUP parameters. Enter a gray of *90* in the swatch. Set HORIZONTAL GAP and VERTICAL GAP to *0.07*. This value determines the tile joint width.

FIG 4.28 Diffuse Channel, Tiles Parameters.

• REFLECTION CHANNEL

Copy the TILES map to the REFLECTION CHANNEL. We want only the tiles to reflect, of course (not the joints between them), so you need to change the color settings. In the TILES map, set the TILES RGB to a gray of *5* for a slight reflection. Set the COLOR VARIANCE to *0.0* once again. The reflection is the same on all tiles. Set the GROUT swatch to *black*.

FIG 4.29 Reflection Channel, Tiles Parameters.

Back in the Reflection settings, remove the link between Hɪʟɪɢʜᴛ Gʟᴏssɪɴᴇss and Rᴇғʟ. Gʟᴏssɪɴᴇss and increase Sᴜʙᴅɪᴠs to *16*. Paste a copy of the modified Tɪʟᴇs map into the Hɪʟɪɢʜᴛ Gʟᴏssɪɴᴇss channel. In the Tɪʟᴇs map, change the Tɪʟᴇs gray to *195* to add a soft highlight to the material.

Tip:
Increase the Bʟᴜʀ to *1.0*. A transition that is too hard can result in undesirable reflection effects.

FIG 4.30 Highlight Glossiness Channel, Tiles Parameters.

- BUMP CHANNEL

Paste the copy of the TILES map from the REFLECTION CHANNEL into the *Bump map* as well. Here, set the TILES swatch to *white*. The tiles are high in relief and the joints are low, so black in the map. An intensity of *10* is sufficient for the BUMP CHANNEL.

FIG 4.31 Bump Channel, Tiles Parameters.

FIG 4.32 Tiles_Small, Channels Overview.

- UVW map, assign material

Select the layers *01_wall_interior_bathroom* and *01_floor_bathroom*. Apply the UVW MAP modifier as before and assign the material.

FIG 4.33 Tiles_Small, Material Editor View.

Wood, Window Frame

The window frames are dark brown wood. It reflects slightly and the Shellac material provides a soft highlight for the rounded edges.

- Create a new VRayMtl *wood_windowframes*.
- Diffuse channel

Place a VRayDirt map into the Diffuse channel. Enter settings of *20 cm* for radius, *1.0* for falloff and *16* for subdivs. Choose a Bitmap in the unoccluded color channel and open the file *wood_window_d.jpg*. Set Length and Width of the texture to *50* cm. We want to see a nicer section of the image texture on the window frame. Set the Offset Width to *25 cm*. The Use Real-World Scale checkbox must be activated.

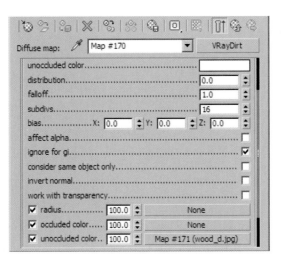

FIG 4.34 Wood_Windowframe, VRayDirt Parameters.

FIG 4.35 Wood_Windowframe, VRayDirt, Bitmap Parameters.

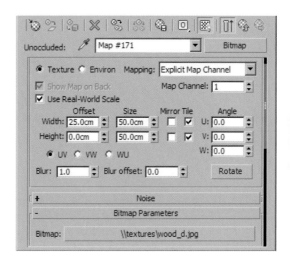

- REFLECTION CHANNEL

Set the reflection intensity to *30*. The material should have a soft reflection, so set REFL. GLOSSINESS to *0.9* and SUBDIVS to *32* to avoid graininess. Remove the link between HIGHLIGHT GLOSSINESS and REFLECTION GLOSSINESS; we will create a highlight by overlaying a SHELLAC material.

FIG 4.36 Wood_Windowframe, Reflection.

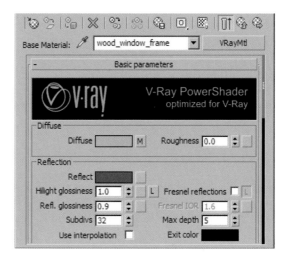

- Shellac material

Create a SHELLAC material with the usual material as the BASE MATERIAL. Set SHELLAC COLOR BLEND to *100*. Change the diffuse color to *black*. In the BLINN BASIC PARAMETERS rollout, paste a copy of the BITMAP from the DIFFUSE CHANNEL. You must first modify it slightly. Increase the RGB LEVEL in the OUTPUT rollout to *20*. With this lightness multiplier, the image becomes lighter and the reflection therefore stronger. Back in the SHELLAC material, adapt the

parameters in the SPECULAR HIGHLIGHTS group. Set the SPECULAR LEVEL (the intensity) to *80*. Enter *35* for GLOSSINESS and *0.5* for SOFTEN.

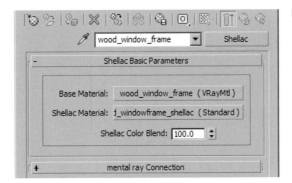

FIG 4.37 Shellac Material, Overview.

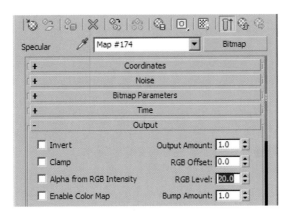

FIG 4.38 Shellac Material, Specular Channel, Bitmap Output Parameters.

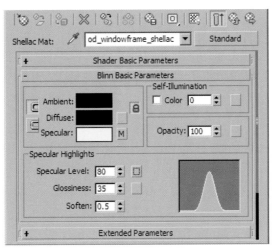

FIG 4.39 Shellac Material Parameters.

- UVW map, assign material

Before assigning the material to the layer *01_window_frame*, apply the UVW MAP modifier to this layer.

FIG 4.40 Wood_Windowframe, Material Editor View.

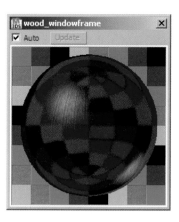

Wood, Light

Apart from the frame of the room divider in the foreground, the bed frame and bedside tables are going to be made from wood with a white finish. We can simply copy the material we just created; then we just need to make a change in the DIFFUSE CHANNEL.

- Copy the material *wood_windowframe* to an empty slot in the MATERIAL EDITOR and rename it *wood_light*.
- DIFFUSE CHANNEL

In the DIFFUSE CHANNEL, change the VRAYDIRT map. Delete the BITMAP from the UNOCCLUDED COLOR channel by right-clicking on it and choosing CLEAR. Enter a gray value of *230* in the UNOCCLUDED COLOR swatch.

FIG 4.41 Wood_Light, VRayDirt Parameters.

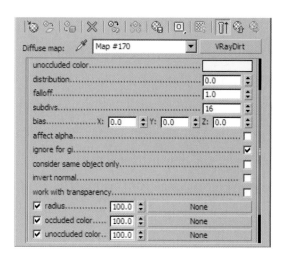

- UVW Map, assign material

Select the layer *01_wood_light* and apply the UVW Map modifier. Then assign the new material to the layer.

FIG 4.42 Wood_Light, Material Editor View.

Paper, Screen

The screen is covered with translucent paper. It is not transparent, but does let light shine through, and has a rough texture.

- Create a new VRayMtl called *paper_screen*.
- Diffuse channel

As the Bitmap in the Diffuse channel, select the file *paper_d.jpg* from the *textures* subdirectory. Set Width to *30 cm* and Height to *20 cm*. Activate the Use Real-World Scale, as usual.

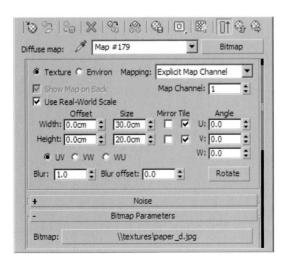

FIG 4.43 Paper_Screen, Diffuse Channel, Bitmap Coordinates.

In this case, you need to crop the image slightly to avoid texture tiling. In the BITMAP PARAMETERS rollout within the CROPPING/PLACEMENT group, click on the VIEW IMAGE button. Crop the image by about *0.15* on each side. Compare with **Figure 4.44**. Close the dialog box and check APPLY.

FIG 4.44 Crop Image, Paper_D.jpg.

FIG 4.45 Paper_Screen, Diffuse Channel, Bitmap Parameters.

- REFRACTION CHANNEL

Set a gray of *50* and enter *1.0* for IOR. The light is not refracted, unlike with glass.

FIG 4.46 Paper_Screen, Refraction.

- BUMP CHANNEL

Copy the BITMAP from the DIFFUSE CHANNEL into the BUMP CHANNEL and reduce the intensity to *5*. A slight relief structure is enough.

- UVW Map, assign material

In the LAYER MANAGER, select the layer *01_screen_paper*. First apply the UVW MAP modifier and then assign the material.

Fabric

The duvet (comforter), mattress, and towel in the bathroom will be assigned a very light gray fabric as the material. It has a soft sheen, which we will achieve with a SHELLAC material.

- Name the new VRAYMTL *fabric*.
- DIFFUSE CHANNEL

In the DIFFUSE CHANNEL, set a light gray of *175*.

- Shellac material

On top of the fabric material, create a SHELLAC material with a SHELLAC COLOR BLEND of *100*. Set the Diffuse swatch for the SHELLAC material to *black*. Change the SPECULAR LEVEL to *65* and GLOSSINESS to *5*.

FIG 4.47 Fabric, Shellac Material, Overview.

FIG 4.48 Fabric, Shellac Material Parameters.

• Assign the material to the layer *01_fabric*. A UVW MAP is not required.

FIG 4.49 Fabric, Material Editor View.

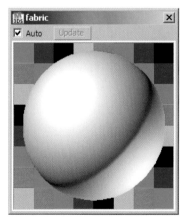

Fabric, Bathmat

The bathmat will have a simple VRayMtl with a VRayDirt map to create a clear contact shadow. A texture on the bathmat would not be noticed, due to the small size in the picture. A copy of the test material that has the same qualities is enough.

Create a copy of the *test material* and rename it *fabric_bathmat*. Assign the material to the layer *01_bathmat*.

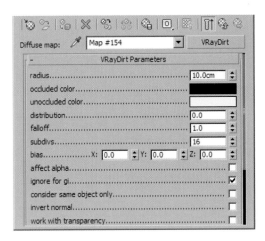

FIG 4.50 Fabric_Bathmat, VRayDirt Parameters.

Ceramic

The ceramic material we use has a white surface. We want the reflection on the material to be view-dependent and to increase in bend.

- Create a new VRayMtl and name it *ceramic*.
- DIFFUSE CHANNEL
 Enter a gray of *230*.

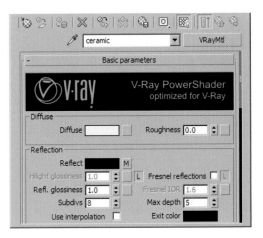

FIG 4.51 Ceramic, Overview.

• REFLECTION CHANNEL

Create a FALLOFF map in the REFLECTION CHANNEL. You need to adjust the curve in the MIX CURVE rollout: right-click on the left point and choose BEZIER-CORNER. Now drag the control point to the bottom-right corner. Now hardly any reflection is visible when the object is viewed from the front, but the reflection increases towards the edges of the sphere in the MATERIAL EDITOR. Compare your settings with **Figure 4.53**.

FIG 4.52 Reflection Channel, Falloff.

FIG 4.53 Falloff, Mix Curve, Adapted Curve.

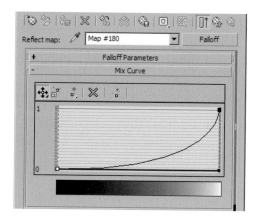

• Assign the material to the layer *01_ceramic*.

FIG 4.54 Ceramic, Material Editor View.

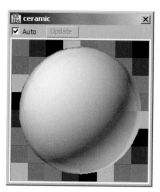

Chrome

The faucet in the bathroom, the bathtub feet, and the handles on the bedside tables are meant to be chrome. We overlay the previously encountered chrome material with a SHELLAC material to create a white sheen along the edges.

- Create a new VRAYMTL *chrome.*
- DIFFUSE CHANNEL

Change the color swatch to *black.*

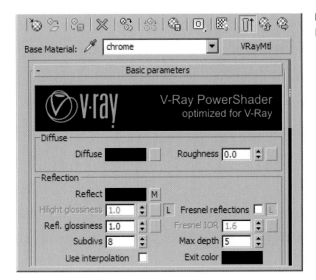

FIG 4.55 Chrome, Overview and Reflection.

- REFLECTION CHANNEL

Create a FALLOFF map in the REFLECTION CHANNEL again. This time, drag the left point upwards to about *0.6.*

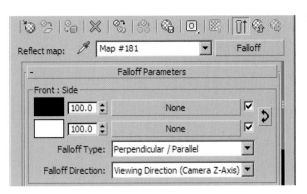

FIG 4.56 Reflection Channel, Falloff.

FIG 4.57 Falloff, Mix Curve,
Adapted Curve.

FIG 4.57 Falloff, Mix Curve,
Adapted Curve.

• Shellac material

Create the SHELLAC material above the VRAYMTL again and change the SHELLAC COLOR BLEND to *100*. In the SHADER BASIC PARAMETERS rollout, choose ANISOTROPIC. The following parameters relate to the ANISOTROPIC BASIC PARAMETERS rollout. Change the color in the Diffuse swatch to *black*. Set SPECULAR LEVEL to *60*, GLOSSINESS to *15* and ANISOTROPY to *90*.

FIG 4.58 Chrome, Shellac Material,
Overview.

FIG 4.59 Shellac Material
Parameters.

FIG 4.60 Chrome, Material Editor View.

- Select the layer *01_chrome* and assign the material.

Mirror Glass

The mirror glass is also a simple VRAYMTL and is completely reflective.

- Name the new VRAYMTL *mirrorglass*.
- Set the color swatch of the REFLECTION CHANNEL to *white* and assign the material to the layer *01_mirror*. The Diffuse color is irrelevant, because the material is completely reflective.

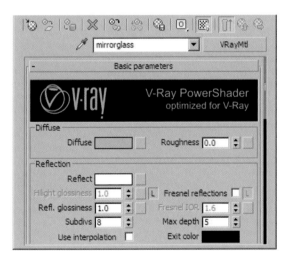

FIG 4.61 Mirrorglass, Reflection.

FIG 4.62 Mirrorglass, Material Editor View.

Lights, Ceiling

The illuminant is embedded within the chromed frame of the ceiling lamps. So far, we have only set up light sources—their origin has not been determined. We will use the VRAYLIGHTMTL, a luminous material, to represent the light sources. We assign two materials to one object, so we will use a multimaterial. We have already assigned the relevant material IDs to the objects.

- Create a new MULTI/SUB-OBJECT material and name it *lights_ceiling*.

Reduce the number of submaterials to two. Drag and drop a chrome material into the top material slot. In the bottom slot, create a new VRAYLIGHTMTL. Leave the default settings in place.

FIG 4.63 Lights_Ceiling, Multi/Sub-Object Material, Overview.

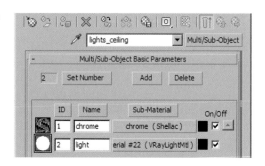

FIG 4.64 Lights_Ceiling, VRayLightMtl Parameters.

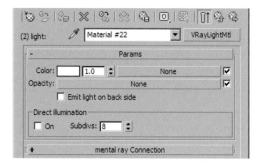

- Assign the material to the layer *01_lights_ceiling*.

FIG 4.65 Lights_Ceiling, Material Editor View.

Glass

Next, we will create the glass for the window panes. Switch the visibility of the layer *01_window_glass* in the LAYER MANAGER back on.

- Create a new VRayMtl *glass*.
- DIFFUSE CHANNEL

Set a *black* color in the DIFFUSE CHANNEL.

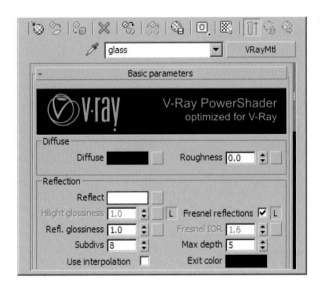

FIG 4.66 Glass, Reflection.

- REFLECTION CHANNEL

Set the color swatch to *white*.

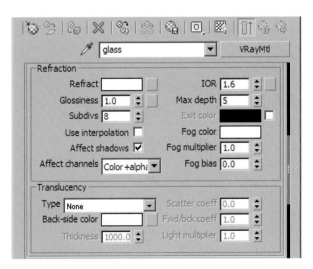

FIG 4.67 Glass, Refraction.

- REFRACTION CHANNEL

For a complete refraction, enter *white*. Select the AFFECT SHADOWS checkbox and select ALL CHANNELS in the AFFECT CHANNELS menu.

- Assign the glass to the layer *01_window_glass*.

FIG 4.68 Glass, Material Editor View.

Glass, Glass Blocks

Last but not least, we will design the glass blocks. You again need to switch on visibility for the layer *01_wall_glassblocks_glass*. The glass is supposed to have a light-blue tint, and we need to increase the number of reflections and refractions to be calculated. We will base this material on the previously created glass.

- Create a copy of the *glass* material in an empty slot. Name the new material *glass_glassblocks*.
- REFLECTION CHANNEL

Set a gray of *125* and increase MAX DEPTH to *10*.

FIG 4.69 Glass_Glassblocks, Reflection.

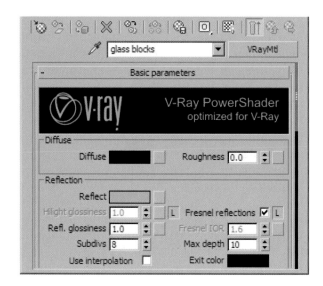

- REFRACTION CHANNEL

Reduce the IOR value to *1.55* to reduce the light refraction slightly. If the refraction is too high, you cannot see anything through the glass wall. Increase MAX DEPTH to *10* again. For FOG COLOR, set the swatch to RGB *195, 240, 250* and reduce the FOG MULTIPLIER to *0.05*.

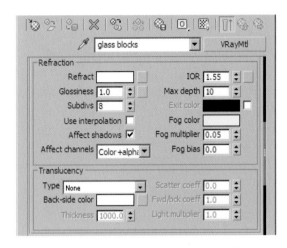

FIG 4.70 Glass_Glassblocks, Refraction.

- Assign the material to the layer *01_wall_glassblocks_glass*.

FIG 4.71 Glass_Glassblocks, Material Editor View.

Fine-Tuning

Now we have assigned all the materials and you can try rendering the scene at a higher resolution, such as *1500 × 750* pixels. Change the following settings in the RENDER SETUP dialog box: set MIN. RATE and MAX. RATE in the ADAPTIVE SUDIVISION IMAGE SAMPLER to *0* and *4*. This makes the resolution finer and brings out more details. In the LIGHT CACHE, increase SUBDIVS to *1500*. Generally, this setting should correspond to the higher resolution value, in this case *1500* pixels. Now render the scene. If you look at your picture afterward, you will notice that the light in the bathroom is still rather dim. To fix this, we will make two changes.

151

Light, Mirror

We want to accentuate the bathroom with a plane light in the mirror. In the Top Viewport, create a new VRayLight and name it *light_mirror*. Place it approximately at center of the object *mirror_frame*. Go to the light source settings, and set Type to Plane; we want to create a plane light. Set Size to a Half-length of *75 cm* and Half-width of *2 cm*. Move the light so that it is inside the mirror frame and directed at the floor.

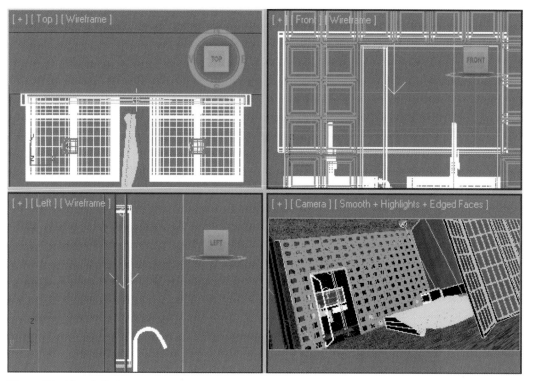

FIG 4.72 Light_Mirror, Positioning.

Compare with **Figure 4.72**. To make sure that you are working in the same light intensity unit (Lumen) as the IES light sources, set Units in the Intensity group to *Luminous power (lm)*. Set Multiplier to *2500* lumen. Set the Color to RGB *240, 250, 250*, which is a light blue. Increase the resolution by setting Subdivs in the Sampling group to *32*.

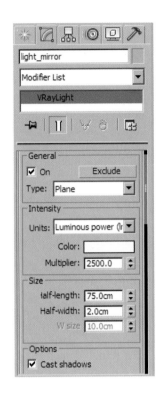

FIG 4.73 Light_Mirror, Parameters.

Adapt Light Sources and Environment

• Adapt light sources

Select one of the light sources, *light_bathroom*, and increase the intensity by setting POWER to *4500*. To improve the light source resolution, set SHAPE SUBDIVS to *64*. Use the same setting for the light source called *light_bedroom*.

• Adapt environment

To bring a more nocturnal atmosphere into the scene—in other words, some dark-blue light—increase the intensity of the environment illumination. Open the RENDER SETUP dialog box and go to the V-RAY tab, then to the V-RAY:: ENVIRONMENT rollout. Set the MULTIPLIER of the GI ENVIRONMENT (SKYLIGHT) OVERRIDE to *6.0*.

You can improve the image contrast by lightening the light colors slightly and darkening the dark image areas, such as shadows. Go to the V-RAY:: COLOR MAPPING rollout. Reduce the DARK MULTIPLIER to *0.9* and increase the BRIGHT MULTIPLIER to *1.2*.

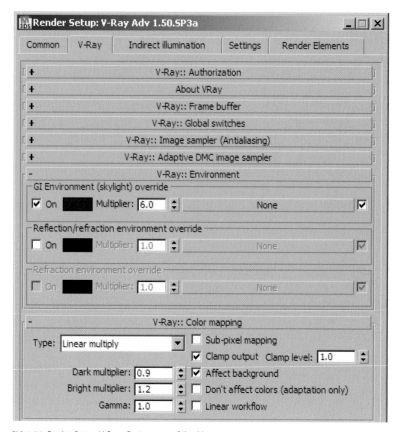

FIG 4.74 Render Setup, V-Ray:: Environment, Color Mapping.

Final Render Settings

Open the RENDER SETUP dialog box and go to the V-RAY tab. The following bullet points each relate to the corresponding rollout.

• V-Ray:: Image sampler (antialiasing)

Set TYPE to ADAPTIVE DMC and choose CATMULL-ROM as ANTIALIASING FILTER. The Catmull-Rom filter produces even sharper, more high-contrast results than the BLACKMAN filter does. The edges of objects in particular are clearly sharper. Both filters are popular for architectural visualizations. This advice applies to image production and cannot be applied to animations. You can see an overview of the filters with sample images in the support area of the Chaos Group web site (http://www.chaosgroup.com).

• V-Ray:: Adaptive DMC image sampler

Set the MIN. SUBDIVS to 4 and the MAX. SUBDIVS to 10.

FIG 4.75 Render Setup, V-Ray:: Image Sampler (Antialiasing).

FIG 4.76 Render Setup, V-Ray:: Adaptive DMC Image Sampler.

Indirect Illumination

Go to the INDIRECT ILLUMINATION tab.

• V-Ray:: Indirect Illumination (GI)

For PRIMARY BOUNCES, choose IRRADIANCE MAP, and for SECONDARY BOUNCES, this time choose LIGHT CACHE.

• V-Ray:: Irradiance map

Set CURRENT PRESET to MEDIUM. For BASIC PARAMETERS, increase the HSPH. SUBDIVS to 80. This means that more rays are emitted during the calculation of the Global Illumination samples, the scene is sampled in more detail, and the quality of the calculated sample is better. With settings of 50 to 100, you usually get a very good result. The number of rays is the square of the value you set here.

Increase INTERP. SAMPLES slightly to 30. During the calculation, more samples are averaged. The scene loses some detail, but the appearance is softer and more harmonious. The image is much less likely to become blotchy in dark areas with fewer samples.

FIG 4.77 Render Setup, V-Ray::
Irradiance Map.

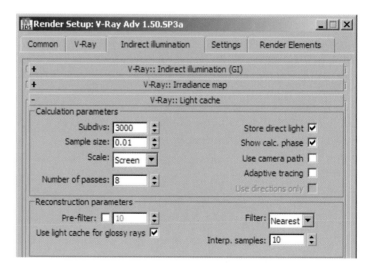

• V-Ray:: Light cache

Set Subdivs to *2500* and Sample size to *0.01*. Check the Use light cache for glossy rays checkbox in the Reconstruction parameters group.

FIG 4.78 Render Setup, V-Ray::
Light Cache.

Render the image with a resolution of *3000 × 1500* pixels. Meanwhile, luxuriate in the knowledge that you have completed another chapter and created an impressively atmospheric picture.

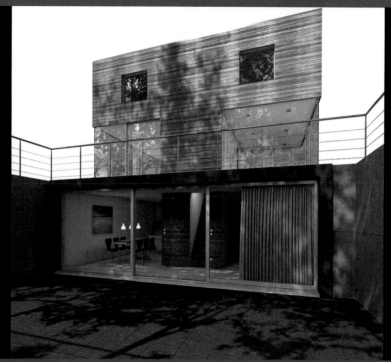

T-Bone House, Exterior

This chapter presents an exterior visualization. Two characteristics distinguish it from the other chapters. First, the T-Bone house is a building that actually exists; it was completed by the Architectural Office COAST (Stuttgart, Germany). The visualization is based closely on the original. Second, we are going to use many materials, due to the complexity and realism of the scene. We therefore start the chapter with a model that has already been largely textured. We will create only materials that have qualities that have not been previously explored in detail in this book. The final rendering should feature reflections and a shadow on the façade. A further complication is that we want to be able to see into the interior, so we need to set up light sources within the building as well. This scene also uses an HDR image for indirect illumination and reflections.

Preparing the Scene

The model for this scene has again been constructed exclusively in 3ds Max. The wooden slats are present as geometry and do not need to be created via a *bump map* or *displacement map*. The same applies for the patio tiles joint

Architectural Rendering with 3ds Max and V-Ray. DOI: 10.1016/B978-0-240-81477-3.00009-0

FIG 5.1 T-Bone House.

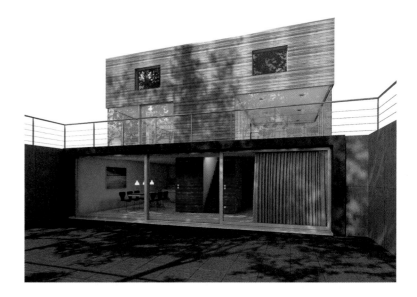

pattern. We want to focus on exterior and interior harmony and add an interesting emphasis to the façade.

Open File

Open the file *ch_05_01.max* from the book CD (*chapters\ch_05*). First, familiarize yourself with the scene. As you can see, many objects already have materials assigned to them.

FIG 5.2 Scene, Overview.

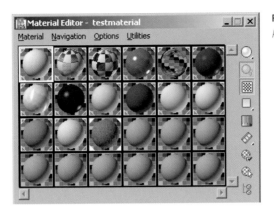

FIG 5.3 Material Editor, Already Assigned Materials.

Also check out the Layer Manager; there are a lot more layers than in the other scenes. We hid the layer *00_shadow_trees*; we will get back to it later. All materials are again assigned to all objects of a layer. Open the Render Setup dialog box. We have already entered some V-Ray settings for you to use. Again, we used a combination of Irradiance map and Light cache.

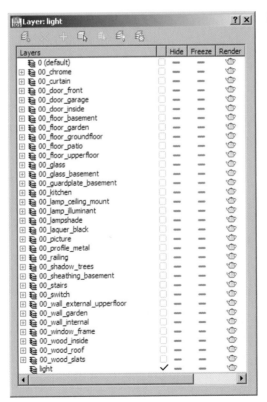

FIG 5.4 Layer Manager.

Camera Setup

Your first action is setting up a camera. The angle from one corner of the yard diagonally towards the house offers an interesting view. Position a new Target Camera in the Top Viewport, at about a quarter of the width of the yard and close to the wall. Move the camera's target towards the bottom of the staircase. Go to the Camera Viewport. Move the camera in the z-direction until is at about the same height as a standing adult. Set an absolute height of *–110 cm*. Now drag the camera target upward as well. Make sure that the ratio of visible ground and air above the building is balanced. We chose an aspect ratio of *3:2* with a lens of *24 mm* and a resolution of *640 × 480* pixels.

FIG 5.5 Camera Setup.

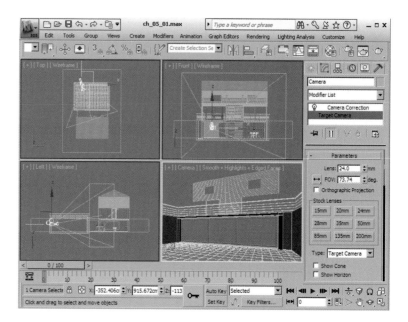

Create Sunlight

Initially, we will set up only one light: the sunlight. This time we are using a simple direct standard light with one target, a Target Direct Light. Its advantage is that it can be easily controlled with few settings. It also works well in combination with a diffuse HDRI illumination, which we will add later.

Create the Target Direct Light in the Top Viewport (Command Panel/Create/Lights/ Standard). Position the light to the right and above the model and the target to about the center of the house. The height of the light source should be similar to that in **Figure 5.6**. Name the light source *sunlight*. Enter the following settings for the light: the Shadows rollout should be set

to VRayShadow and the Intensity/Color/Attunation rollout should have the Multiplier for light intensity set to *1.0*. In the color swatch next to it, enter the RGB values *250, 240, 220* for a natural light color. Set the Directional Parameters rollout to Circle to make the light source circular. The parameters Hotspot/Beam and Falloff/Field influence the spread of the light. We do not want a falloff of light intensity, so set both parameters to *3000 cm*. In any case, the light source diameter should be larger than the model.

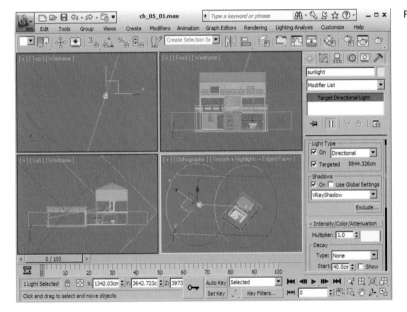

FIG 5.6 Create Sunlight.

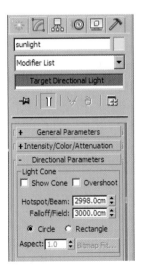

FIG 5.7 Sunlight, Parameters.

Go to the VRaySHADOWS PARAMS rollout. The checkboxes for TRANSPARENT SHADOWS and AREA SHADOW should be activated. To make the sun look realistic, select the option SPHERE. The values U, V, W determine the SIZE of the SPHERE. Set each of them to *10 cm* for a sphere with a diameter of *10 cm*. The higher the values, the softer the shadow edges will be.

FIG 5.8 Sunlight, Further Parameters.

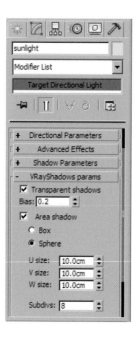

Activate the indirect illumination in the RENDER SETUP dialog box's INDIRECT ILLUMINATION tab. Then render the scene. You will notice that the contrast is very high. This should not bother you at this stage.

FIG 5.9 Render Setup, V-Ray:: Indirect Illumination (GI).

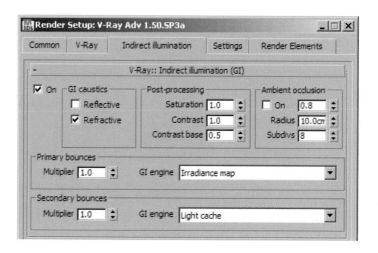

Tip
Activate gamma correction in the V-Ray FRAME BUFFER by clicking on the DISPLAY COLORS IN sRGB SPACE button.

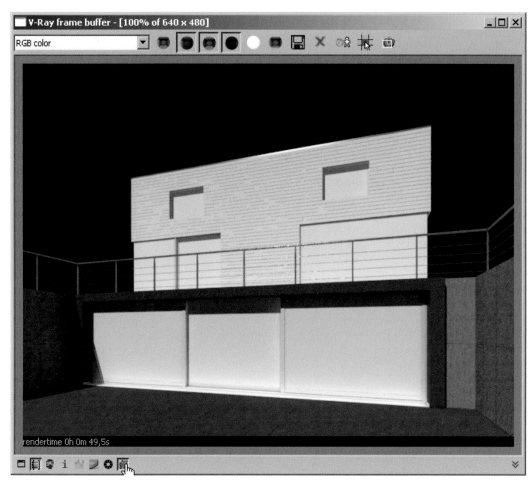

FIG 5.10 V-Ray Frame Buffer.

Create Additional Materials

In the next section, we are going to create the missing materials. Apart from a wood cladding that emphasizes the characteristic T shape of the house, we need materials for window frames and window panes.

Wood, External

The external walls on the ground floor and upper floor have naturally weathered wood cladding. In this case, we modeled the slats and joints, which makes the joint structure emerge more clearly than if we had used a *bump map*. We use the *bump map* just to emphasize the wood texture. Again, we overlay the wood with a SHELLAC material to achieve a soft sheen. To reduce the sheen in dark, deep areas of the

wood texture, we place a grayscale bitmap into the SHELLAC material's REFLECTION CHANNEL.

- Create a new VRAYMTL *wood_external* in the MATERIAL EDITOR.
- DIFFUSE CHANNEL

Place a VRAYDIRT map into the DIFFUSE CHANNEL. Change the parameters for RADIUS to *10 cm*, FALLOFF to *1.0*, and SUBDIVS to *16*. Select a BITMAP in the UNOCCLUDED COLOR channel. Open the picture *wood_external.jpg* from the *textures* subdirectory. Make sure that USE SYSTEM DEFAULT GAMMA is selected in the SELECT BITMAP IMAGE FILE dialog box, to satisfy the linear workflow (LWF). In the BITMAP settings, select the USE REAL-WORLD SCALE checkbox and determine the dimensions of the map. Set WIDTH to *150 cm* and HEIGHT to *75 cm*. Activate the SHOW STANDARD MAPS IN VIEWPORT option in the MATERIAL EDITOR to ensure that the texture is visible on the objects in the VIEWPORT later on.

FIG 5.11 Wood_External, VRayDirt Parameters.

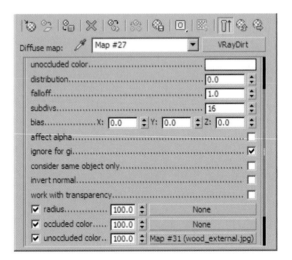

FIG 5.12 Wood_External, VRayDirt, Bitmap Parameters.

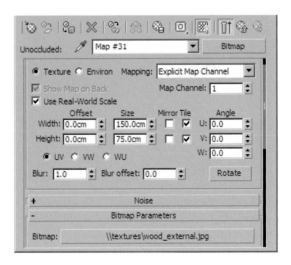

- BUMP CHANNEL

Place a BITMAP in the BUMP CHANNEL as well. Choose the picture *wood_bump-spec.jpg*. Proceed as in the DIFFUSE CHANNEL. Set the dimensions of the texture to the same size. For BUMP MAPPING INTENSITY, use the preset value of *30*.

FIG 5.13 Wood_External, Bump Channel, Bitmap Parameters.

- Shellac material

Create a SHELLAC material above your VRayMtl *wood_external*. Choose the option KEEP OLD MATERIAL AS SUBMATERIAL. Set SHELLAC COLOR BLEND to *100*. In the SHELLAC material, change the Diffuse color to *black*. Set the SPECULAR LEVEL (the intensity) to *50* and GLOSSINESS to *30*. The material now shows a slight, soft, but even sheen. To maintain this sheen on only the light parts of wood and not in the grooves of the texture, create a grayscale BITMAP in the SPECULAR channel. This map is analogous to the *Bump map*—the deeper areas are also dark. So you could just paste a copy of the *Bump map*. In the MATERIAL EDITOR, you can see the variation.

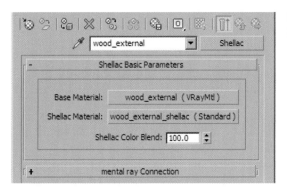

FIG 5.14 Wood_External, Shellac Material, Overview.

165

FIG 5.15 Shellac Standard Material, Parameters.

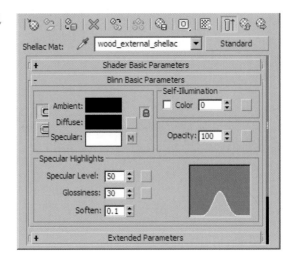

- UVW map

In the Layer Manager, select the layers *00_wood_slats* and *00_wood_roof* and assign the UVW Map modifier to the selection in the Modify tab of the Command Panel. Make sure that the Mapping for the modifier is set to Box and that the Real-World Map Size checkbox is activated.

FIG 5.16 Wood_External, Material Editor View.

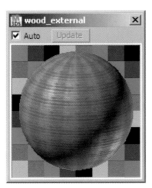

- Assign material

Open the Layer Manager. Select the layer *00_wood_roof*. Assign the material. In the Top Viewport, activate the Shading (press F3), and you will notice that the wood texture on the roof is rotated in relation to the external walls. Even if that is not visible from the current camera position, it is best to correct it. Activate the UVW Mapping modifier gizmo of the layer *00_wood_roof*. Rotate it by 90 degrees around the z-axis.

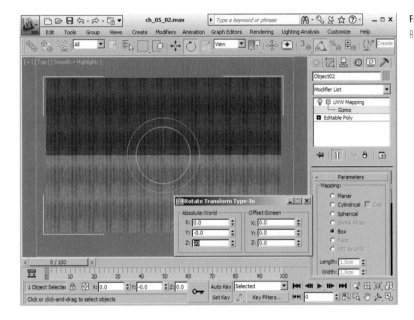

FIG 5.17 Layer 00_Wood_Roof, Rotate Gizmo.

Wood, Interior

The walls in the interior also feature wood cladding—they optically extend the T. Here we can use the material *wood_external*, with a few changes. The texture dimensions are the same, but the surface inside the house is smooth, varnished, and unweathered.

• As we have not yet assigned a glass material for the basement windows, first make the layer *00_glass_basement* invisible in the LAYER MANAGER. Now we can see inside.

FIG 5.18 Material Editor, Hide Layer 00_Glass_Basement.

- Create a copy of the BASE MATERIAL *wood_external* and rename it *wood_internal*.
- DIFFUSE CHANNEL

In the VRAYDIRT map, in the UNOCCLUDED COLOR channel, replace the BITMAP image with the image *wood_internal.jpg*. Unlike the image of the material *wood_external*, this one has a higher saturation and represents unweathered wood.

FIG 5.19 Wood_Internal, VRayDirt Parameters.

- BUMP CHANNEL

Delete the map from the BUMP CHANNEL. The wood inside the house has a varnished, smooth surface, so it does not require a relief texture.

- REFLECTION CHANNEL

Give the material a high-quality, slightly reflective surface by setting the color swatch to *10*.

FIG 5.20 Wood_Internal, Reflection.

- UVW map

In the Layer Manager, assign a UVW Map with Box Type to the layer
00_wood_internal.

- Assign the material to the layer *00_wood_internal.*

FIG 5.21 Wood_Internal, Material
Editor View.

Glass

The next step is creating the glazing for the windows on the ground floor
and upper floor. We want a light glass that is about 10 percent reflective,
partially keeping its own color. This is sensible, because the building
edges on the ground floor are defined by the glass and should not
disappear.

- Create a new VRayMtl *glass.*
- Diffuse channel

Set a *white* color in the Diffuse channel.

- Reflection channel

Set the color swatch to a gray; use RGB *25* for each setting. We will not use
a Fresnel reflection, as the window panes are not curved and the effect is
not really visible.

- Refraction channel

For a complete refraction, set the color to *white*. Activate the Affect Shadows
checkbox and set Affect Channels to Color+alpha. This ensures that light
passes through the glass and that the transparency is output in the alpha
channel.

- Assign the glass to the layer *00_glass.*

FIG 5.22 Glass, Reflection.

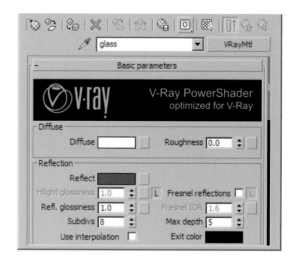

FIG 5.23 Glass, Refraction.

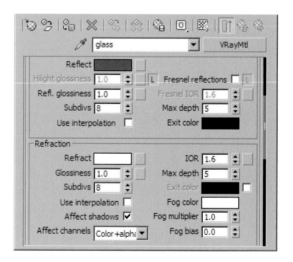

FIG 5.24 Glass, Material Editor View.

Glass, Basement

For the window panes in the basement, we need to slightly modify the glass used previously. We want to be able to see into the interior, as is often desirable for exterior visualizations. In reality, this is rarely possible, as the environment brightness during the day is much higher than inside a room and the environment is therefore fully reflected by the glass. In our rendering, we will reduce the reflection intensity to create the desired result.

* In the LAYER MANAGER, make the layer *00_glass_basement* visible again.
* Copy the material *glass* to an empty slot and name it *glass_basement*.
* REFLECTION CHANNEL

Reduce the reflection intensity to *15* to create greater transparency.

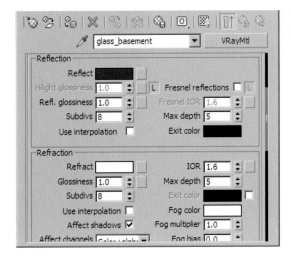

FIG 5.25 Glass_Basement, Reflection and Refraction.

* Assign the material to the layer *00_glass_basement*.

FIG 5.26 Glass_Basement, Material Editor View.

Window Frame, White

The next material to be assigned is the one for the window frames. These have a white, metallic reflective surface.

- Create a new VRayMtl *windowframe_white*.
- Diffuse channel

In the Diffuse channel, we again use a VRayDirt map. Give it a gray color of *230* in unoccluded color. The other settings are *20 cm* for radius, *1.0* for fallout, and *16* for subdivs.

FIG 5.27 Windowframe_White, VRayDirt Parameters.

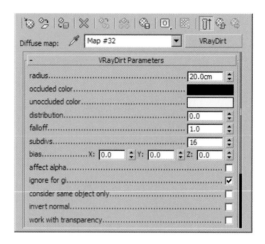

- Reflection channel

Set the reflection amount to *40*. The material should have a soft reflection, so set Refl. Glossiness to *0.95* and subdivs to *32* to avoid graininess. Remove the link between Highlight glossiness and Reflection glossiness, as we will create a highlight by overlaying the Shellac material.

FIG 5.28 Windowframe_White, Reflection.

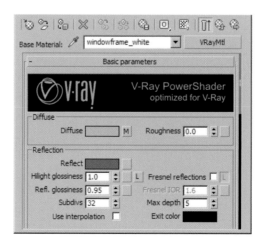

- Shellac material

Create another SHELLAC material with the previous material as the BASE MATERIAL. Change the diffuse color to *black*. This time we want to simulate a metallic material, so set SHADER BASIC PARAMETERS to ANISOTROPIC. Metallic surfaces have, depending on the surface handling, a direction dependent (anisotropic) reflection. This is caused by very fine grooves on the surface that are caused by polishing or brushing. In the ANISOTROPIC BASIC PARAMETERS group, set SPECULAR LEVEL to *40*, GLOSSINESS to *25*, and ANISOTROPY to *80*. The highlight on the material has now changed to a soft, diagonal stripe.

FIG 5.29 Windowframe_White, Shellac Material, Overview.

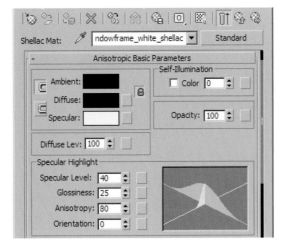

FIG 5.30 Shellac Standard Material, Parameters.

- In the LAYER MANAGER, assign the material to the layers *00_windowframe*, *00_guardplate_basement*, and *00_door_garage*.

FIG 5.31 Windowframe_White,
Material Editor View.

Light Inside

Let's add some extra focus to the interior. At the moment, you can see inside, but it's still rather dark and dull in there, especially the kitchen. As we have set up three hanging lamps in the kitchen above the table, it makes sense to equip these with light sources. We will set up another light source above the stairs to brighten that area some more.

Light, Kitchen

Create a new VRAYLIGHT (COMMAND PANEL/CREATE/LIGHTS/V-RAY/VRAY-LIGHT) and name it *light_kitchen*. In the TOP VIEWPORT, move it into the center of one of the ceiling lamps, and in the LEFT VIEWPORT, move it to just beneath the illuminant. It should still be within the lampshade.

FIG 5.32 Clone Options, Instance.

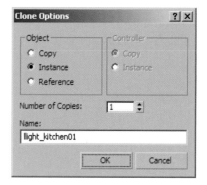

In the Top Viewport, create one copy each as Instance for the other two lamps. Go to the settings for one light source (Command Panel/Modify). We want to simulate a lightbulb, so the light source should have Sphere as Type. To achieve a pleasantly warm light tone, set the color swatch to RGB *240, 210, 135*. Specify the light intensity by setting the Multiplier to *10*. The radius of the spherical light source does not have to be limited to the dimensions of a lightbulb; with a radius of *10 cm*, you will approximately fill the lampshade and achieve a good result with soft shadows. Make sure that the Cast Shadows and Invisible checkboxes are activated. This ensures that shadows are cast and makes the light source invisible. Because these settings are instances, they are adopted for the other copies. The other lights "inherit" the qualities of the first.

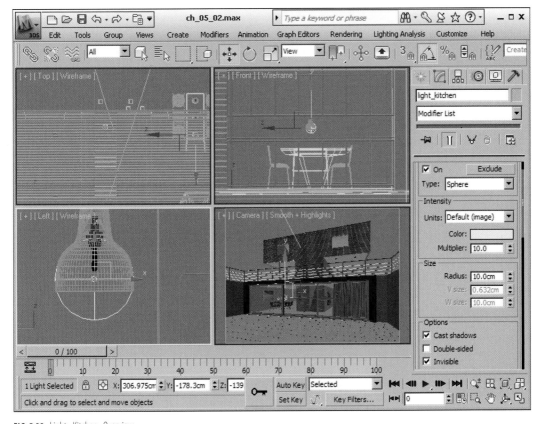

FIG 5.33 Light_Kitchen, Overview.

In the next rendering, you will see that the kitchen is now pleasantly lit, the lampsshades are shining, and the chairs cast soft shadows on wall and floor.

Tip
The lampshade material has to be translucent. Have a look at it in the Material Editor.

FIG 5.34 V-Ray Frame Buffer, Light_Kitchen.

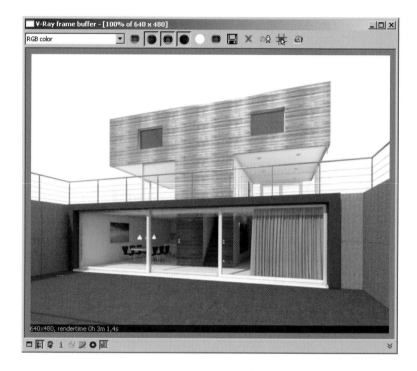

Light, Stairs

We want to make the stairs a little bit brighter. This area is too dark; we can create the impression of light falling from the upper floor onto the stairs. Create a copy of the kitchen light, this time with the clone option COPY. Rename it *light_stairs*.

FIG 5.35 Clone Options, Copy.

Position the light source in the TOP VIEWPORT at the center of the third step. Go to the LEFT VIEWPORT and move the light to about *20 cm* above the ground level of the upper floor or Absolute *20 cm* in the z-direction. You still need to increase the MULTIPLIER for the intensity to *30*.

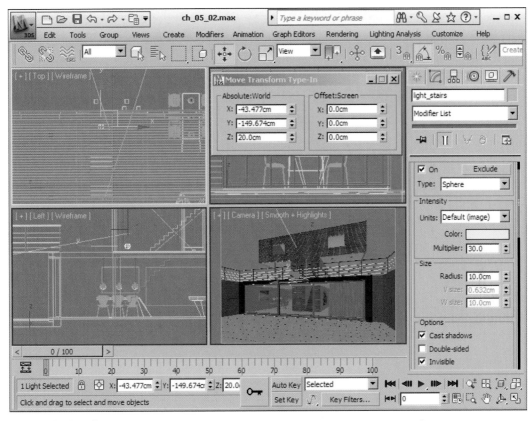

FIG 5.36 Light_Stairs, Overview.

HDRI Illumination

As we are not using a VRAYSUN as light source, our scene is currently
illuminated by only a standard light source. Next, we are going to add
a diffuse illumination by using an HDRI image in the V-Ray Environment.
It will also help us create reflections on the façade. Open the RENDER
SETUP dialog box and go to the V-RAY:: ENVIRONMENT rollout in the V-RAY
tab. Override all channels by activating the checkboxes on their left.
Then click on the GI ENVIRONMENT (SKYLIGHT) OVERRIDE channel and
choose VRAYHDRI.

Drag and drop this map to an empty MATERIAL EDITOR slot and rename
it *HDRI_Illumination*. For HDR MAP, select the image *environment.hdr* from
the *textures* folder on the book CD. Then set MAP TYPE to SPHERICAL
ENVIRONMENT. V-Ray loads these HDR images with a gamma value of *1.0*, so
you need to set GAMMA to the reciprocal of 2.2 (1 divided by 2.2), which is
0.455. Set the image rotation (HORIZ. ROTATION) to −*60*, which brings the
reflections out well.

FIG 5.37 Render Setup, V-Ray::
Environment.

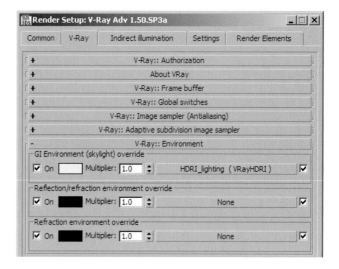

FIG 5.38 Material Editor,
HDRI_Illumination.

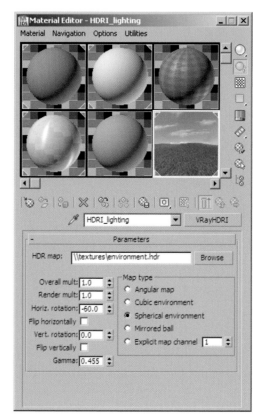

In the RENDER SETUP dialog box, drag a copy of this map to the REFLECTION/
REFRACTION ENVIRONMENT OVERRIDE channel. In the REFRACTION OVERRIDE channel, you
can leave the color set to *black*—we want to override only the reflection.

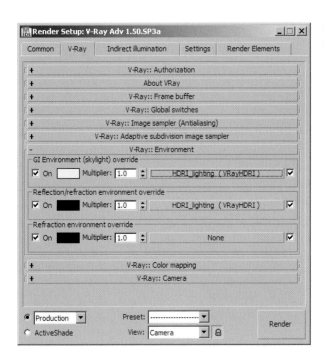

FIG 5.39 Render Setup, V-Ray::
Environment.

Render the scene. The atmosphere now seems much less artificial and the façade is no longer completely homogeneous.

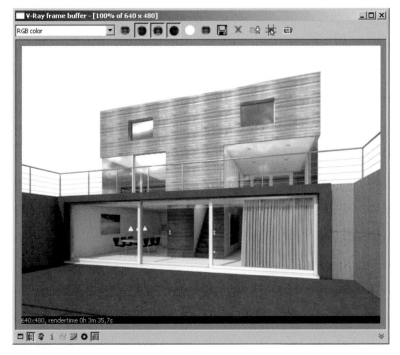

FIG 5.40 V-Ray Frame Buffer,
HDRI_Illumination.

Tip
Reactivate visibility for the layer
00_shadow_trees in the
Layer Manager.

Fine-Tuning: Shadows on the Façade

In the last step, we add another effect: shadows are cast onto the façade by planes behind the camera, to which we assign a tree texture.

- Create a new V-Ray material.
- Name the VRayMtl *tree_big*.
- Diffuse channel

Create a Bitmap in the Diffuse channel and use the image *tree_a.jpg* from the *textures* folder. This time, make sure that the Use Real-World Scale checkbox is deactivated. Offset should be set to *0.0* and Tiling to *1.0*. We do not need a UVW Map; the Bitmap is applied to the size of the area at a 1-to1 ratio. Activate Show Standard Maps in Viewport in the Material Editor.

FIG 5.41 Tree_Big, Diffuse Channel, Bitmap Parameters.

- Opacity channel

The Opacity channel determines via a grayscale texture which image areas are visible and which are opaque. Drag a copy of the Bitmap from the Diffuse channel to the Opacity channel. Replace the picture *tree_a.jpg* with *tree_a_alpha.jpg*. In this picture, only the tree areas are white; the rest is black and will therefore not show.

- Assign the material to the three large planes in the layer *00_shadow_trees*.

To create the texture for the three smaller planes, create a copy of the material and rename it *tree_small*. Replace the image *tree_a.jpg* in the Diffuse Map with *tree_b.jpg*. Also replace the image *tree_a_alpha.jpg* with *tree_b_alpha.jpg*. Assign this material to the three small planes.

FIG 5.42 Tree_Big, Opacity Channel.

FIG 5.43 Tree_Big, Opacity Channel, Bitmap Parameters.

FIG 5.44 Tree_Big, Material Editor View.

FIG 5.45 Scene, Tree_Big and Tree_Small Assigned.

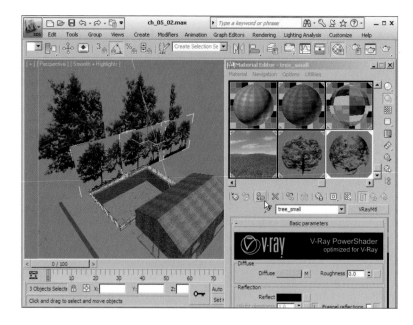

Render the scene. You now have a nice shadow over the whole picture. To take some of the shadow's sharpness away, because it seems too pronounced, go to the sunlight settings. In the VRaySHADOWS params rollout, increase the values for the U, V, W size setting to *20 cm* each and SUBDIVS to *32* to achieve better resolution of the soft shadow edges.

FIG 5.46 Sunlight, Parameters.

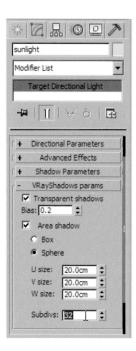

Final Render Settings

V-Ray

Open the RENDER SETUP dialog box and go to the V-RAY tab. The following bullet points each relate to one rollout.

- V-Ray:: Image sampler (antialiasing)

Set TYPE to ADAPTIVE DMC and ANTIALIASING FILTER to BLACKMAN.

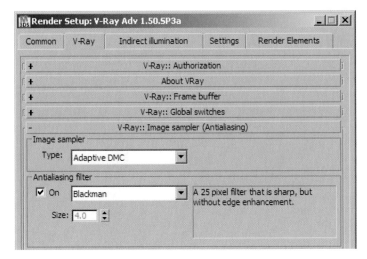

FIG 5.47 Render Setup, V-Ray:: Image Sampler (Antialiasing).

- V-Ray:: Adaptive DMC image sampler

Set MIN. SUBDIVS to 2 and MAX. SUBDIVS to 6.

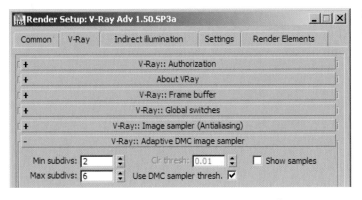

FIG 5.48 Render Setup, V-Ray:: Adaptive DMC Image Sampler.

Indirect Illumination

Go to the INDIRECT ILLUMINATION tab.

- V-Ray:: Indirect Illumination (GI)

Set PRIMARY BOUNCES to IRRADIANCE MAP and SECONDARY BOUNCES to LIGHT CACHE.

- V-Ray:: Irradiance map

For CURRENT PRESET, choose MEDIUM. Increase the BASIC PARAMETERS settings for HSPH. SUBDIVS to *60* and INTERP. SAMPLES to *20*.

FIG 5.49 Render Setup, V-Ray:: Irradiance Map.

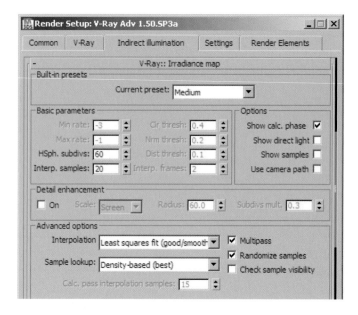

- V-Ray:: Light cache

Change the SUBDIVS setting to *2500* and SAMPLE SIZE to *0.01*. Activate the option USE LIGHT CACHE FOR GLOSSY RAYS.

FIG 5.50 Render Setup, V-Ray:: Light Cache.

Render the image with a resolution of *2500 × 1875* pixels. Make sure to store the alpha channel when saving the image.

FIG 5.51 TIF Image Control, Store Alpha Channel.

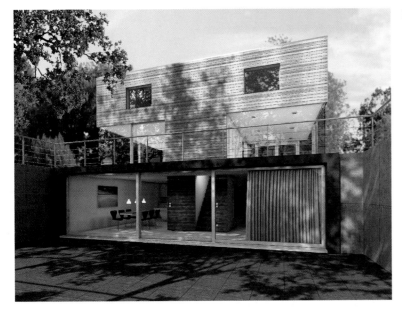

FIG 5.52 Rendering, Integrated In Photograph.

You can now easily insert a background during further processing with an image editing program. For our example, we inserted a few trees and a sky, as well as tinting the whole picture slightly. Congratulations, you have completed another chapter! Now you are able to use HDR images for illuminating scenes and creating reflections. This method has a lot of potential and can help you create scenes that are amazingly realistic.

Studio Setup

This chapter addresses a simple studio setup—an environment used primarily with product visualizations. The setup is comparable to a photo studio. Here, the challenge lies in bringing out product shape and material qualities. Diffuse light provides even illumination and soft shadows.

Preparing the Scene

We are making the model of a lamp available for your studio setup. You can then create a background, illuminate the scene step by step, and assign the material.

Open File

Open the file *ch_06_01.max* from the companion CD (*chapters\ch_06*). This lamp was also constructed in 3ds Max. Open the LAYER MANAGER, and you will find that all parts of the lamp are already sorted into layers according to their material. Acquaint yourself with the scene. To arrange your next steps more clearly, create two new layers: *light* and *canvas*. Set the layer *canvas* as current layer.

Architectural Rendering with 3ds Max and V-Ray. DOI: 10.1016/B978-0-240-81477-3.00010-7

FIG 6.1 Studio Setup.

FIG 6.2 Scene, Overview.

FIG 6.3 Layer Manager, Overview.

Background and Camera

At the moment, our lamp is standing in empty space. We need a surface for it to stand on and a background. In a studio setup, you would usually use an L-shaped plane with rounded corner so that it has a fluent transition from floor to background.

Create Canvas

Go to the LEFT VIEWPORT. Use the LINE tool to create an angle, as shown in **Figure 6.4**, with the dimensions *200 cm* for length and width. Name this line *canvas*.

FIG 6.4 Draw Line.

In the COMMAND PANEL, choose VERTEX and mark the corner point. Use FILLET to round the corner. Choose a setting of *25 cm*. Apply the EXTRUDE MODIFIER with a setting of *200 cm* to your *canvas*. The corner is now rounded. In the rendering, these settings create a gradient in the background.

FIG 6.5 Canvas, Choose Vertex, Apply Fillet.

FIG 6.6 Round Edge.

You still need to align the canvas with TOOLS/ALIGN/ALIGN…. Center the canvas so that it's in the middle of the x- and y-axes; in the z-axis, it should be flush with the object *stand* of the lamp.

FIG 6.7 Align Canvas with Lamp.

FIG 6.8 Align Selection, X, Y Position.

FIG 6.9 Align Selection, Z Position.

Camera Setup

To set up the camera, go to the FRONT VIEWPORT. Create a FREE CAMERA. To get the fewest possible distortions, choose a wide lens and position the camera further away from the lamp. A *200mm* lens is a good choice. Due to the lamp proportions, an aspect ratio of *1:2* is best. The format is often not relevant for a studio setup, as the rendering will most likely be isolated and then placed into a new background. Set the resolution to *240 × 480 pixels*. Position the camera as in **Figure 6.10**.

FIG 6.10 Camera Setup, Overview.

Illuminate Scene

The aim of product visualization is to enhance the object's shape, material, and color. Round shapes are emphasized with brightness variations; edges with targeted highlights. We can achieve it by using a neutral background and diffuse illumination of the scene with plane lights.

Create Test Material

As in the previous scenes, you first assign a neutral, almost white material to all objects. Open the MATERIAL EDITOR, create a new VRayMtl, and name it *test material*. Select the VRayDirt material in the DIFFUSE CHANNEL and set the gray of the UNOCCLUDED COLOR to *230*. Unlike with rooms or buildings, we are now working with a very small object, so decrease the radius to *3.0 cm*. Set FALLOFF to *0.5*. Increase the SAMPLING in the SUBDIVS parameter to *16* to get a clean result. Select all objects in the scene and assign the *test material*.

FIG 6.11 Test Material, VRayDirt Parameters.

Create Plane Lights

In the following steps, we create a plane light: a key light to the right of the lamp and a so-called fill light opposite on the left.

- Key light

Go to the LEFT VIEWPORT. Create a VRayLight (COMMAND PANEL/CREATE/LIGHTS/V-RAY/VRayLIGHT) and name it *key light*. If it is not set already, change TYPE (COMMAND PANEL/MODIFY) to PLANE. You have now created a rectangular light source. You can change its dimensions with HALF-LENGTH and HALF-WIDTH (these designate half the length from the center). Set each to *100 cm*. Move the light source until it slightly overlaps the canvas on the left and at the bottom. In the TOP VIEWPORT, position it about *50 cm* to the right of the lamp. Compare with **Figure 6.12**. The light color is also important. The lamp is made mainly from the cool materials glass and chrome. The key light should also have a cool color to emphasize the nature of these materials. Set COLOR to RGB *220, 240, 230*. This corresponds to a very light

Tip
In the Render Setup dialog box's V-Ray:: Global Switches rollout, deactivate the Hidden Lights checkbox and set Default Lights to Off with GI.

blue. Leave the intensity at *1* and make sure that UNITS is set to DEFAULT (IMAGE).

• Fill light

As you can deduce from its name, the *fill light* has a more subtle character. Copy the *key light* with the MIRROR tool (TOOLS/MIRROR). Use the method COPY with an OFFSET of *−100 cm*. Rename the copy *fill light* and shift it upwards in the TOP VIEWPORT by about *70 cm* in the y-axis. The bottom edge should be a little bit underneath the lamp. This lets the light fade into the background and illuminates only the back, left part of the lamp. The *fill light* needs a warmer tone to achieve a soft gradient on the round areas, and it should have a lower intensity. Change the COLOR to RGB *255, 220, 170* and reduce the MULTIPLIER to *0.5*.

FIG 6.12 Create Key Light and Fill Light, Overview.

Tip
Activate Gamma correction in the V-Ray FRAME BUFFER by clicking on the DISPLAY COLORS IN sRGB SPACE button.

Now it is time to check the results again. Open the RENDER SETUP dialog box. Activate V-RAY:: INDIRECT ILLUMINATION (GI) in the INDIRECT ILLUMINATION tab. Set PRIMARY BOUNCES to IRRADIANCE MAP and SECONDARY BOUNCES to LIGHT CACHE. In the V-RAY:: IRRADIANCE MAP rollout, set the CURRENT PRESET to LOW; in the V-RAY:: LIGHT CACHE rollout, reduce SUBDIVS to 500.

That should be enough for a preview. Render the image. The effect of the light sources can be assessed well with the test material and a short render time.

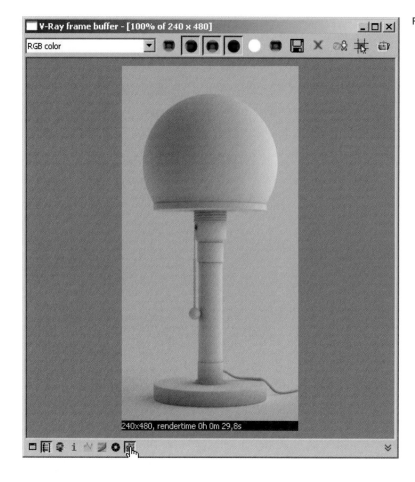

FIG 6.13 V-Ray Frame Buffer.

Texture the Scene

Now we want to bring the lamp to life. Apart from chrome, glass is the main material, and is present in the scene in three variations: the lamp base is shimmering green solid glass; the lamp shade is made from white opaque glass; and parts of the stand are clear glass.

Canvas

The *canvas* in the background should be as neutral as possible. We chose a dark gray in contrast to the bright lamp.

- Create a new VRayMtl in the Material Editor and name it *canvas*.
- Diffuse channel

Use the Color Selector dialog box to enter RGB 15, 15, 15.

FIG 6.14 Canvas, Overview.

- Assign the material

Assign the material to the object *canvas*.

Chrome

Many parts of the stand and the lamp's pull switch chain are chrome.

- Create a new VRAYMTL and name it *chrome*.
- DIFFUSE CHANNEL

Change the color to *black*.

- REFLECTION CHANNEL

Select a FALLOFF map. This makes the reflection depend on the viewing direction. That part of the sphere that faces the viewer appears black and does not reflect. The reflection gets stronger toward the edges of the sphere. Chrome does reflect a little from any angle, so you need to change the black to a medium gray. Enter for the black swatch for FRONT:SIDE an RGB setting of *125, 125, 125*. Click on the L next to HIGHLIGHT GLOSSINESS to deactivate its link with REFLECTION GLOSSINESS, and set HIGHLIGHT GLOSSINESS to *0.8*. This overlays the sharp chrome reflection at the edges with softer highlight and emphasizes the contours.

- Assign the material

In the LAYER MANAGER dialog box, select the layer *00_chrome* and assign the material.

FIG 6.15 Chrome, Reflection.

FIG 6.16 Falloff Map, Parameters.

FIG 6.17 Chrome, Material Editor View.

Clear Glass

The middle section of the lamp stand is a cylinder of transparent glass. The power cable runs through this cylinder in a narrow chrome tube. The clear glass has a subtle blue tint.

* Create a new VRayMtl and name it *glass_clear*.
* Change the color swatches for the Diffuse, Reflection, and Refraction channels to *white*.
* Reflection channel

Activate the Fresnel reflections checkbox.

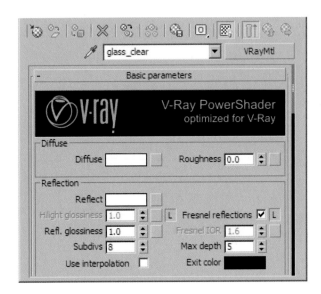

FIG 6.18 Glass_Clear, Reflection.

* Refraction channel

Create a Falloff Map in the Refraction channel. Set Falloff Type to Fresnel and swap the white and black color swatches (Swap colors/Maps).

FIG 6.19 Glass_Clear, Falloff Map Parameters.

In the Mɪx Cᴜʀᴠᴇ, add a new point slightly to the right of the bottom-left point. See **Figure 6.20**. This achieves a light haze in the glass edge areas, which makes it stand out better from the background. You avoid the risk that the glass becomes completely transparent at the edges and therefore invisible.

FIG 6.20 Mix Curve, Adapted Curve.

Now tint the glass very slightly by using the Fᴏɢ ᴄᴏʟᴏʀ parameter; set this to *220, 255, 255*. You also need to adjust the Fᴏɢ Mᴜʟᴛɪᴘʟɪᴇʀ to *0.01*. Activate the Aꜰꜰᴇᴄᴛ Sʜᴀᴅᴏᴡs checkbox and set Aꜰꜰᴇᴄᴛ ᴄʜᴀɴɴᴇʟs to Cᴏʟᴏʀ+ᴀʟᴘʜᴀ.

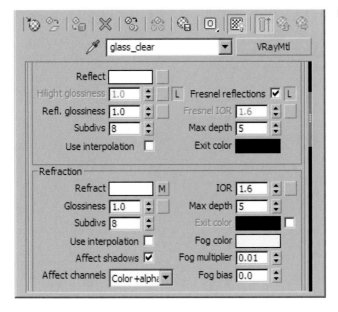

FIG 6.21 Glass_Clear, Refraction.

- Assign the material to the layer *00_glass*.

FIG 6.22 Glass_Clear, Material Editor View.

Glass, White

The lamp shade is made from opaque glass.

- Name the newly created VRᴀʏMᴛʟ *glass_white*.
- Dɪꜰꜰᴜꜱᴇ ᴄʜᴀɴɴᴇʟ

Set the glass color to *white*.

- Rᴇꜰʟᴇᴄᴛɪᴏɴ ᴄʜᴀɴɴᴇʟ

We want the glass to be about 60 percent reflective. Use a gray with a setting of *155* for each value and activate the Fʀᴇꜱɴᴇʟ ʀᴇꜰʟᴇᴄᴛɪᴏɴꜱ checkbox.

FIG 6.23 Glass_White, Reflection.

- REFRACTION CHANNEL

As the glass is not very transparent, change the REFRACT value to a gray with the setting *30*. Again, check AFFECT SHADOWS and set AFFECT CHANNELS to COLOR +ALPHA. Assign this material to the layer *glass_white*.

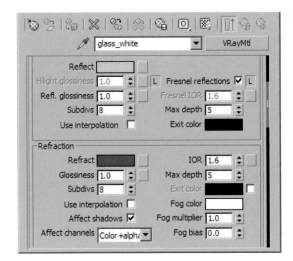

FIG 6.24 Glass_White, Refraction.

FIG 6.25 Glass_White, Material Editor View.

Glass, Solid

The lamp base is a cylinder of shimmering green solid glass. We will use the *fog* effect again.

- Name the new material *glass_solid* and create it in an empty slot.
- Set a *white* color for the DIFFUSE, REFLECTION, and REFRACTION CHANNELS.

Activate FRESNEL REFLECTIONS in the REFLECTION group and AFFECT SHADOWS under REFRACTION. In the AFFECT CHANNELS list, choose COLOR+ALPHA. To create the green shimmer, click on the color swatch next to FOG COLOR. The desired effect is

achieved with RGB settings *180, 255, 220* (a light turquoise). In this case, set the Fog MULTIPLIER slightly higher, to *0.2*.

FIG 6.26 Glass_Solid, Reflection.

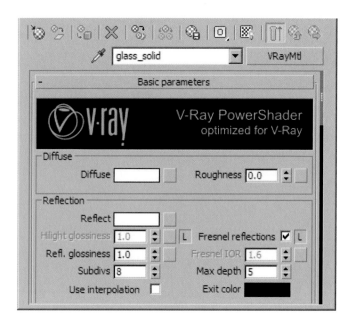

FIG 6.27 Glass_Solid, Refraction.

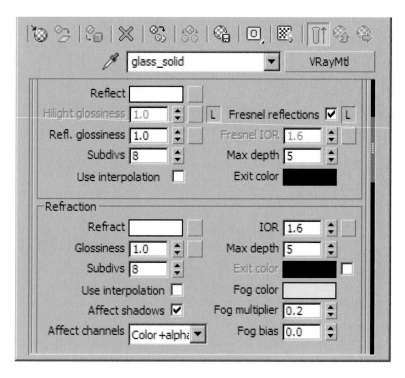

- Assign the material to the layer *glass_solid*.

FIG 6.28 Glass_Solid, Material
Editor View.

Plastic

A less spectacular material—plastic—is also used in the scene. The cable at the lamp's base and a hardly noticeable rubber seal will be assigned this material. We use the SHELLAC material to achieve highlights on rounded areas.

- Create a new VRAYMTL and name it *plastic*.
- In the DIFFUSE CHANNEL, choose a gray set to *10*; we do not need reflection.

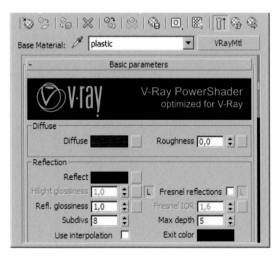

FIG 6.29 Plastic, Overview.

- SHELLAC material

Click on the material selection next to the material name, which currently shows VRAYMTL. Select the SHELLAC material in the dialog box that opens. Choose the option KEEP OLD MATERIAL AS SUB-MATERIAL. The original VRAYMTL *plastic* is now the BASE material and the new SHELLAC material is below it.

The Shellac color blend parameter determines how much the Shellac material will overlay the Base material. A setting of *100* is usually a good choice.

FIG 6.30 Plastic, Shellac Material, Overview.

Go into the Shellac material. It is a Standard material. Change the Diffuse color to *black*, which means that there is no color overlay—only the highlight will be superimposed. You control this highlight with the parameters in the Specular Highlights group. Set the Specular Level (the intensity) to *35*. Glossiness should be *25* and Soften *25*. Now you can see a soft highlight on your plastic material.

FIG 6.31 Plastic, Shellac Standard Material, Parameters.

• Assign the material to the layer *plastic_black*.

FIG 6.32 Plastic, Material Editor View.

Fabric

The upper part of the pull-switch is a fabric-coated string. For this final material in our scene, we will make use of the VRAYDIRT map.

• Create a copy of the test material and rename it *fabric*.
• Go to the VRAYDIRT map in the DIFFUSE CHANNEL. Change the UNOCCLUDED COLOR RGB to *200, 200, 180*. Increase the RADIUS to *10 cm*, FALLOFF to *0.2*, and SUBDIVS to *32*. You now have a slightly beige material with a stronger light-to-dark gradient.

FIG 6.33 Fabric, V-RayDirt Parameters.

- Assign the material to the layer *fabric*.

FIG 6.34 Fabric, Material Editor View.

Now is a good time to render the scene with a higher resolution, such as *1000 × 2000* pixels. Do not be too exact with your V-Ray settings. A quick result can be achieved with the following settings in the Render Setup dialog box:

- V-Ray:: Image sampler (antialiasing)

Use the Adaptive subdivision sampler with the Area filter.

- V-Ray:: Adaptive subdivision image sampler

Set Min rate to *−1* and Max rate to *2*.

- V-Ray:: Indirect Illumination (GI)

Use Irradiance map for Primary Bounces and Light cache for Secondary Bounces. Set the Preset for the Irradiance map to Low. For the Light cache settings enter *1000* for Subdivs with a Sample size of *0.02* (Screen).

FIG 6.35 Render Setup, V-Ray:: Light Cache.

Fine-Tuning

The result looks rather promising. As in the other chapters, we now just need to put the cherry on the top. We can clearly improve our scene by adding a rim light behind the lamp in the camera direction that illuminates only the edges of our lamp. Our studio setup is based on a popular method, the so-called *three-point lighting*, which involves a *key light*, a *fill light*, and a *rim light* (also called a *back light*).

Rim Light

Create a copy of your *fill light* and name it *rim light*. Rotate it by *90 degrees*; the arrow must point toward the camera. Move it to about the same position as shown in **Figure 6.36**.

FIG 6.36 Create Rim Light, Overview.

Now you need to adjust the settings. The light color should be *white*. It is very important to activate the INVISIBLE checkbox, as we do not want the light to be visible. Set the light intensity (MULTIPLIER) to *1.0*. To fine-tune the reflections and brightness variations, you can adjust the position of the *key*

light and the *rim light* slightly. We decided to move both lights away from the lamp by about *5 cm* in the x-axis.

FIG 6.37 Rim Light, Parameters.

You can achieve an interesting reflection on the glass tube by lifting the *fill light* by *2 cm* and the key light by *5 cm* in the z-axis. The *rim light* should be positioned at an absolute height of *105 cm*. If you then render the image, you can move the light sources slightly in order to see the differences. The position of the lights has a decisive impact on the reflections and the material perception. Check the light calculation resolution for all light sources. The SAMPLING group for every light source should be set to *32* for SUBDIVS, *0.02 cm* for SHADOW BIAS, and *0.001* for CUTOFF.

Final Render Settings

V-Ray

Open the RENDER SETUP dialog box and go to the V-RAY tab. The following bullet points each relate to one rollout.

- V-RAY:: IMAGE SAMPLER (ANTIALIASING)

Set TYPE to ADAPTIVE DMC and ANTIALIASING FILTER to BLACKMAN.

FIG 6.38 Render Setup, V-Ray:: Image Sampler (Antialiasing).

- V-RAY:: ADAPTIVE DMC IMAGE SAMPLER

FIG 6.39 Render Setup, V-Ray:: Adaptive DMC Image Sampler.

Set MIN. SUBDIVS to *2* and MAX. SUBDIVS to *6*.

Indirect illumination

Go to the INDIRECT ILLUMINATION tab.

- V-RAY:: INDIRECT ILLUMINATION (GI)

Set PRIMARY BOUNCES to IRRADIANCE MAP and SECONDARY BOUNCES to BRUTE FORCE this time. This produces an almost noise-free gray background.

- V-RAY:: IRRADIANCE MAP

Set CURRENT PRESET to HIGH. Increase the BASIC PARAMETERS settings for HSPH. SUBDIVS to *60*.

209

FIG 6.40 Render Setup, V-Ray::
Irradiance Map.

- V-RAY:: BRUTE FORCE GI

Change the SUBDIVS setting to *10* and SECONDARY BOUNCES to *4*.

FIG 6.41 Render Setup, V-Ray::
Brute Force GI.

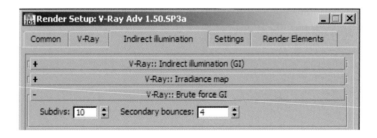

Render the image with a resolution of *2000 × 4000* pixels. Excellent job—
you have completed the final chapter! This studio setup can provide the
basis for many product visualizations; simply adapt and redesign it
according to your needs. Just as in photography, it is important to find the
setup that best suits the object you want to present.

Index

Page numbers followed by *f* indicates a figure and *t* indicates a table

UNIVERSITY OF WOLVERHAMPTON
LEARNING & INFORMATION SERVICES